Draw Me a Story

Draw Me a Story

An Illustrated Exploration of
Drawing-as-Language

Bob Steele

PEGUIS PUBLISHERS

WINNIPEG • MANITOBA • CANADA

© 1998 Bob Steele

First Printing 1998

Canadian Cataloguing in Publication Data
Steele, Bob, 1925-

Draw me a story

ISBN 1-895411-82-3

1. Drawing—Study and teaching. 2. Storytelling.
3. Drawing, Psychology of. I. Title.

NC593.S844 1998 741 C98-920099-X

Cover drawing by Geoffrey
Title page drawing by Sylvan
Book design by Bill & Thomas Stewart
Front & back cover design by David Ashcroft
Printed and bound in Canada by Kromar Printing

PEGUIS
PUBLISHERS
100-318 McDermot Avenue
Winnipeg, Manitoba
Canada R3A 0A2
Toll free: 1-800-667-9673

Contents

Preface

When a child scribbles on a sheet of paper or makes crude chalk pictures on the sidewalk, a language is beginning to emerge. Young children draw with enthusiasm and meaningfulness, yet this potential language resource is almost universally overlooked in homes and schools. We see evidence of children's drawing in playschools, kindergartens, and early primary classrooms, where it is accepted and even appreciated as a spontaneous activity of innate value and a positive influence on literacy. Still, it is undernourished in the early years and, in the intermediate years, drawing almost universally disappears. We have failed to recognize drawing's significance as a language medium for older children and for those with learning or emotional problems. We have not understood its potential in subjects throughout the curriculum.

We are aware of the concerns about standards of literacy and the problems involved in teaching and learning the required skills. We know that, even though children master the mechanics, many are left with no love for reading and writing. Others are exposed to unsuitable teaching methods, or come from homes not enriched by conversation and reading. Drawing could make the acquisition of literacy skills more pleasurable and more efficient.

This book will show that drawing is a language in its own right and, when children practice it daily, it is almost as natural to them as speaking. It contributes to intellectual development and emotional health at a time when children are still struggling to learn the codes of literacy.

When I began to work on this book, I was motivated by two strong impressions gained during many years of supervising student teachers. First, there appeared to be no rationale to support drawing-as-language, either in teacher training institutions or in schools. Second, drawing carried an aura of mystery for many teachers which prevented them from attempting to teach it. It was used in classrooms, if at all, as a pleasant adjunct to serious learning, mostly for decorating and illustrating project booklets.

I want to show that generalist teachers with no background in art can use drawing as a language for learning throughout the curriculum. Any change from present practice, however, will depend on developing a rationale. If it can be shown that drawing is a language, we must then treat it as seriously as other language media.

Acknowledgments

I am not alone in writing this book. Two years before retiring from the Faculty of Education at the University of British Columbia, I founded the Drawing Network*, a grassroots organization of parents, teachers and educators dedicated to drawing-as-language. Nine semi-annual issues of a newsletter of the same name were distributed to a mailing list which grew to over 2,000. I also wrote

..

*For information about The Drawing Network, address correspondence to: Bob Steele, Associate Professor (Emeritus), University of British Columbia, Faculty of Education, Department of Curriculum Studies, 2125 Main Mall, Vancouver, BC, Canada V6T 1Z4.

pamphlets on aspects of drawing-as-language which were distributed to teachers through school district offices. They form the basis for this book.

I am indebted to the many teachers, parents, administrators and academics who have made donations to the Drawing Network, have written letters and short pieces, and have sent me photocopies of drawings for the newsletter. Of the hundreds of letters received, all have been supportive and helpful and many of the drawings appear here. Some individuals have contributed extensively and deserve special mention. My sincere thanks go to all of the following.

To Sue Leung for the many outstanding drawings from her private art classes, including Zion's *Boat Holiday*, and for her enthusiastic interest and encouragement during the period of writing. Through Sue, Drawing Network contacts have been made in Hong Kong and China and at least one pamphlet has been translated into Chinese. Nadine Guiltner, a kindergarten/primary teacher in Likely, BC, used drawing in an integrated curriculum long before there was a Drawing Network. She exemplifies the growing number of teachers who recognize the value of drawing as a language medium and an influence on literacy. I thank the principal and staff of South Park Family School in Victoria, the first school to my knowledge to have a daily drawing program. This school has provided many drawings and examples of enlightened teaching which have inspired me. Marne St. Claire, my eldest daughter, who is a generalist/music/art teacher at South Park, has contributed boundless enthusiasm, detailed editing and practical advice.

The Hudson family introduced me to Joanne and shared her unique drawings over the years. Katherine Reeder, the teacher who arranged for the drawing workshops at Carnarvon Community School, Vancouver, inspired the section on Mayan studies. Susan van Gurp wrote to the Drawing Network about Felicitas and Ryan, whose drawing appear in Chapter Four. The Kwok family

and Zion, whose drawing *Boat Holiday* contributed to several chapters, motivated me to formulate the theory of 'aesthetic energy and the occasional achievement of work of art.' The Kwok family (same name, different family) and their children Laura and Lawrence shared their happy family life which nurtured both literacy and drawing. Beth Colpitts, my youngest daughter, and her husband Doug, both teachers, contributed valuable advice and editing.

Wendy Burden contributed the drawings inspired by the novel *The Cay* by intermediate children at Norquay Elementary School in Vancouver. David Steele, my son, a practising artist, contributed a number of key drawings from his childhood, particularly *Attacking the Snake.* June Meyer, Professor of Early Childhood Education at University College of the Fraser Valley, supplied the extraordinary drawings made by her kindergarten children at the Museum of Anthropology. Chris Medley, now a librarian in Vancouver, gave me permission to use extensive portions of his childhood book, *Hockey and Football.* Dr. Gloria Snively, University of Victoria, permitted me to use drawings of marine specimens in Chapter Nine. They are from a book soon to be published, *Exploring Beaches with Kids.*

I thank Dr. Eleanor Irwin for the wonderful story (Chapter Four) she told to a gathering at the University of Victoria in the mid-70s which I have used in my teaching ever since; David MacLean and his son Danny for permitting me to tell their story in Chapter Four and to quote extensively from his letters; Professor Jang Jingzhi from China who has supported the Drawing Network from the beginning; and Wing Chow, who gave me the lithograph, *Oil Spill,* by Samuel, from his high school printmaking studio, used in Chapter Three as an example of empathic realism.

Without the illustrations, this book would not have been possible. To the children and young people who made the drawings I extend heartfelt thanks. They are:

Geoffrey, Sylvan, David, Zion, Leo, Denise, Michael, Campbell, Nicholas, David, Danny, Tyler, the drawer of *My Mom and Dad Screamed...*, Norman, James, Lawrence, Janika, Franky, Tony, Judy, John, Eileen, Andy, Caleb, Stefan, Samuel, Marne, Laura, the drawer of *You I'm Going to Kill*, Beth, the drawer of *Caged Dog*, Byron, Blake, Brandon, the drawers of *Soccer, Hockey, and Baseball*, Danny, Felicitas, Ryan, Michael, Steven, UBC game drawers, UBC student printmakers, Blake, Benjamin, Sandra, Erika, Blake, Richard, the drawer of *Slaying the Dragon*, Isadora, Jon, Jessica, Zoe, Arne, the Museum of Anthropology drawers, Marcus, Edward, Bernice, Howie, the drawers of microscopes, eggbeater, saxophones, sunflower, toads, flowers, and *Two Fish and a Crab*, Kate, Cory, David, Edwin, the drawer of *Flying Frog*, David, Leanna, Robert, Mike, Cameron, students of Carnarvon School, Tyler, Jeff, Eddie, Jayme, Alexis, Wendy, Edward, Loan, Monica, Sherman, Vincent, Philip, and Neal.

Bob Steele

Chapter 1

● ● ● ● ● ● ● ● ● ● ● ● ● ● ● ●

An Introduction to the Unrecognized Language of Childhood

I once pulled into a highway rest stop to enjoy a coffee break. In the next car there was a young family. It was an attractive picture, the father holding his baby aloft in hands which easily encircled her tiny body, their faces inches apart, the mother leaning toward them sharing a moment of grace. Seeing this family brought to mind the quotation from *Magical Child*. Nothing is so likely as a baby to move us to thoughts of human potential, or stir us to wonder about our "innate capacities." A baby carries in every cell an infinitely complex heritage, a convergence of ancestral lines. And so much lies in the future, an unfolding dependent on a loving family, a nurturing community, and a healthy environment. The baby was earnestly communicating, using the only 'language' available to her, eye contact, fists clenching and unclenching, arms that flailed, and, above all, the babbling sounds that anticipate words. I was observing the beginnings of language, that most awe-inspiring of mind capacities.The parents knew she was communicating; her body language radiated happiness, curiosity, dependence, and love. Soon she would begin to mimic the single words said to her with provocative teasing by her parents: "moma," "dada," and so on. Before long she would be scribbling and

Our innate capacities of mind are nothing less than miraculous and we are born with a driving intent to express them.

— *Joseph Chilton Pearce**

*From *Magical Child*. New York: Bantam Books, 1980. First published by E.P. Dutton, 1977.

exploring the beginnings of drawing, a second language. As soon as she became old enough to hold a crayon or pencil, she would make her first marks on paper, applied at first tentatively, and then boldly. They would remind her of familiar objects which she would name, looking to her parents for confirmation. In the next stage of development, she would make drawings to represent the people and things most important to her and possibly these would correspond to her first words. Mom would be drawn as a 'tadpole' figure, a single circle for head/body, extended lines for legs, arms, fingers and toes. Faces would radiate happiness and affection; smiles would be drawn with a single line spreading from ear to ear. This would be an exciting time, a major step along the path to visual literacy.

Most children draw when the materials to do so are at hand. For the most part their scribbles and early representations are neither encouraged nor discouraged, simply accepted with benign interest. In such an atmosphere, the use of coloring books and formula art kits are considered toys or are misconstrued as an "art experience." These attitudes towards art and art education are deeply ingrained in our culture. Art is generally viewed as a life-enhancing hobby, a pursuit for those who have time, money, or talent. Rarely is art viewed as essential or, indeed, of interest to the individual or society.

In schools, a great deal of time is devoted to mastering the complex codes of literacy. It is generally scheduled in the high energy morning hours and carried into other subjects throughout the day. I have no wish to change this emphasis, simply to broaden the definition of language. Drawing gets very little attention in school. Many teachers recognize it as an aid to literacy but rarely as a language in its own right. Formula art (providing images for coloring-in, making uniform craft objects and seasonal decorations)

makes no use at all of children's creativity, yet it is still widely practiced, even when authentic drawing is considered part of the language program.

If these attitudes are to change, teacher training programs must play an important role. Even there, drawing has not been generally recognized as a language phenomenon, as being critically important to intellectual and emotional maturity. Human development textbooks, an important part of every teacher's professional preparation, typically devote only a few pages to the arts, fewer to the visual arts, still fewer to drawing as a developmental phenomenon, and none to drawing-as-language. These texts do make good points: they refer to developmental stages as hallmarks of growth; they point out the importance of providing a rich array of building materials for pre-school and kindergarten children, and they recognize and applaud the social values and self-esteem that accrue from arts involvement. But in general, the attention given to the arts suggests tokenism.

How can we establish better goals? If spurious practice is unacceptable, how can authentic practice be defined? We can begin by recognizing children's drawings for what they are: artifacts from the child's mental life; the products of the child's imagination; attempts to make sense of the world in whatever medium is available and most easily used.

I advocate an approach to home/school education that would free children to use all their "innate capacities of mind." This would be done by shifting drawing from the periphery of the art class to the core of the curriculum as a language medium. In effect, I envisage the use of three languages: words alone, drawings alone, and drawings and words in close collaboration.

The Three Dimensions of Children's Mental Activity

The way children explore their world in any language medium involves three dimensions: perceptual, intellectual, and affective.

The first dimension is perceptual, the manifold involvement of the senses. Not every sensory experience leads to language use; indeed, most are language-free. Children don't clutter up their minds with words every time they see a flower any more than we do, nor do they run for their drawing tools. Of all the sensory experiences we have, only the most stimulating motivate a language response.

The second dimension is intellectual. We needn't be specialists in cognitive theory to appreciate the richness of a child's intellectual life. Sensory experiences inevitably lead to the child noticing phenomena, seeing relationships, and asking questions.

The third dimension is affective, having to do with feelings and emotions. In educational theory, it has been easy to link perception and intellect but the affective life is somehow separated from the others. Yet feelings and emotions are closely linked to intellectual activities. Certainly, if the emotional environment is negative, learning suffers; if it is positive, learning flourishes. (In letters to the Drawing Network, many parents and teachers have commented that drawing improves learning.)

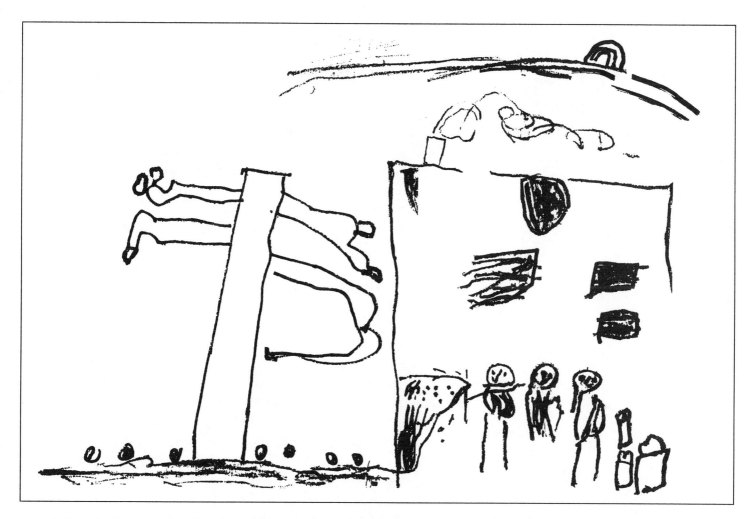

A drawing by my grandson David (figure 1.1) illustrates the three dimensions of mental activity: perceptual, intellectual, and affective. David was looking out the window at a stormy sky when he saw his first rainbow. With great excitement in his voice, he called to his mother to come and see it. Later, the rainbow became part of a birthday card for me drawn with colored felts, a series of three tiny semi-circles in yellow, blue, and red, barely discernible in the upper right corner. The rest of the drawing was of my imagined birthday party.

Figure 1.1 *Birthday Drawing for Grandpa* by David, age 5.

The party is shown in a rectangular house with a smoking chimney offering warmth and hospitality. There are balloons on the ceiling, many presents, and three figures standing in a row, Grandpa, Grandma, and Uncle David. Grandpa is holding a sparkler. This is an x-ray drawing and we see both the inside and outside of the house. Outside, a horse chestnut tree dominates the front boulevard. There are chestnuts on the lawn.

The drawing is filled with sensory references: rainbow, sky, smoke, tree, leaves, chestnuts, sparklers, and colored balloons. It is also charged with feeling. The party was drawn affectionately as he imagined it. He also remembered a happy time when he and his brother were visiting and collected horse chestnuts which they took home to make conkers. Oddly, the rainbow which motivated the drawing is hardly noticeable. From the multitude of perceptions children experience, only a few will be articulated through language, but it provides a rich soil for ideas to emerge like healthy young plants. The rainbow David saw dominated the sky. The one in his drawing is vivid, but small and off to one side. His mother asked, "Why is the rainbow so small, David?" He replied, "Because I'm sending this drawing to Grandma and Grandpa and that's the way it would look to them." Remarkably, from a vivid perceptual experience, he moved on to reason that the rainbow would look smaller from a distant city.

From Disorder to Order: Egocentric Infancy to Social Maturity

Adults scarcely remember the complex world of early childhood: the kaleidoscopic sensory impressions, the dramatic shifts of emotion, the intense interest in natural and social phenomena. Intellectual growth may be characterized as

creating order out of disorder, affective growth as a gradual change from egocentric infancy to social maturity. Children grow individually and socially by interacting with their world, and language is the medium that facilitates this growth. Because their literacy skills are still developing, they intuitively use the medium most likely to satisfy their needs: words for practical communication, drawings for expressing more subtle and complex thoughts. Vocabulary and syntax, the primary characteristics of language, are also found in children's drawings. Children use graphic units (schemata) much as we use vocabulary, and the thought processes that go into drawing — raw materials organized into meaningful and expressive forms — are syntactical in nature.

If drawing is a language, why hasn't it had more impact on home/school education? There are several factors which have contributed to this relative neglect. The first is tradition. Most people still think of language solely as the study of words. While we might refer to the 'language of dance or music,' it is meant metaphorically. In curriculum design and subject evaluation, language means literacy. We have also traditionally thought of language primarily as a medium through which children communicate their needs and moods, but it is much more. Language is the way children make sense of their world and, in doing so, develop their minds.

Next, drawing is not only the unrecognized language but the misunderstood language. Speech emerges, even in an environment of neglect, propelled by the need to communicate and by the ever-present verbal models that surround children. Scribbles, on the other hand, may go unnoticed or even receive a reprimand! The emergence of representational forms may be regarded as charmingly naive, an insignificant stage that children go through. It may seem an anomaly that acquiring speech demands of children that they learn a difficult code from little more

than ordinary models of conversation, while drawing, without a code, depends on careful nurturing. The difference is obvious: spoken language is everywhere and speech requires only the voice; drawing has few models and requires the eyes, the hand, something to mark on, and something to mark with. Drawing-as-language withers on the vine without readily available materials and the ongoing interest and motivation of caring adults.

Finally, the recognition of child art as a phenomenon is relatively new. However, drawings by a child appear on early manuscripts found in the thirteenth-century city of Novgorod by the Russian archeologist, Valentin Yanin.* A boy named Onfim practiced his alphabet and made drawings on pieces of birch bark, drawings that bear a striking resemblance to those of contemporary children. The titles sound like familiar themes: "Onfim striking his enemy," "Onfim and his father on horseback," and "People holding each others' hands." But this account is a rare one. Children's drawings began to be noticed only at the turn of the century by progressive art educators such as Franz Cizek, early twentieth century artists such as Pablo Picasso, and later by psychologists such as Viktor Lowenfeld and philosophers such as Herbert Read. A burgeoning interest began after the end of World War II, and art education became an academic discipline with university departments, doctoral dissertations, research fellowships, subdisciplines and annual conventions. This had an enormous effect on art education, but little on language education.

Some educators claim that art simply takes too much time to be generally useful in the core curriculum, although most recognize its value as a separate subject. Instead, I advocate the use of line drawing. Less complex than other art media, line drawing is the most economical of time and materials; it is more intimately connected to

......................................

*Reported in *School Arts*, Vol. 84, No. 7, March 1985.

literacy than are other art forms, and it is easily integrated into the curriculum. Line has several advantages. It is the drawing technique children use most naturally; it captures the essence of perceived forms; it embodies ideas and knowledge; and expresses feelings and emotions. When we consider the language values of line drawing, dare we reject its assimilation into the home/school curriculum?

How This Book Is Organized

The task I have set myself with this book is to provide a rationale for drawing-as-language and a method for teaching it. I have intermingled these themes in each chapter. The first five chapters are focused on child art and drawing-as-language, the remaining five on teaching strategies and methods.

I hope the book will be read in two ways: first, for an overall picture; second, as an ongoing reference, particularly for teachers. I tried to combine theory and practice so that individual chapters would make sense without having to search for earlier references. When a theoretical point (empathy, for example) is involved in the explanation of a drawing strategy, I review it again in order to avoid having to flip back and forth. A certain amount of repetition has resulted which I hope will not be burdensome.

Who will find this book useful

- kindergarten and primary teachers who recognize the value of drawing as a language and as an aid to literacy
- intermediate and secondary teachers who don't know what to do about the "I can't draw" syndrome, but want to include drawing as a language resource
- parents who want home/school education to embrace the whole child

- young people and adults who wish to teach themselves to draw
- specialist teachers in language arts, science and social studies who wish to broaden the use of language in their subjects
- art teachers who see in drawing an opportunity to develop authentic imagery for use in other visual arts media
- educational psychologists, art educators, and early childhood specialists at colleges and universities using a holistic approach to pedagogy
- young people in secondary schools, colleges, and universities considering a career in teaching
- community activists and concerned citizens committed to changing education for the better

Do I have to be able to draw to teach drawing?

You don't have to have drawing skills yourself in order to teach children to draw. Motivation is the key. If you want to learn with them, so much the better; the book will tell you how you can teach yourself. So long as you respond to the intellectual and emotional needs of children, your skill level in drawing is unimportant. You are not expected to give demonstrations on paper or the blackboard.

It is important to be convinced, however, that drawing is a language, and is vitally important to intellectual development and mental health. Your conviction will help you to motivate students and to understand the importance of daily drawing in their lives.

The Drawings: A Source of Pleasure

In Chapter Five, I show that great artists like Picasso, Klee, and Miro admired the naive work of children. I develop a theory of aesthetic energy to account for it and relate it to learning and mental health. Aesthetic energy is real in child art, even though it is on a much lower frequency than in the works of masters. We want to avoid dismissing the art of children as mere cuteness and learn to appreciate its authentic content and form. All else aside, the drawings are there to be enjoyed as aesthetic objects.

Children's drawings tell us what they think and feel

Thoughtful analysis of children's drawings will give insight into what they think and feel. Here is an outline of what to look for.

Perceptual Content: evidence of sensory impressions; abstract representations (schema) that show the child's growing inventory of objects, persons, and situations; references to self, family, community, and nature; evidence of perceptual acuity and discrimination; (see, in particular, Chapter Two)

Intellectual Content: cause and effect relationships; evidence of factual material being gathered, organized, categorized, priorized; that comparisons are made, themes sustained, problems solved; the presence of humor; (see, in particular, Chapter Two)

Affective Content: the expression of feelings and emotions, positive and negative; signs of sibling rivalry and other family problems, emotional problems at school, indications of catharsis and therapy, early signs of an interest in religious feeling, oneness with community and oneness with nature; (see, in particular, Chapter Four)

Aesthetic Content: aesthetic energy in children's drawings in the relationships of forms to other forms and form to content; (see in particular, Chapter Five)

Illustrations as a Source of Teaching Themes

Drawing as Metaphor
The Castle Shaped Like a Person by Campbell,
 Chapter Two, page 26

Drawing as Invention
Mole Getting Mad at Drill Machine by Nicholas,
 Chapter Two, page 27
Microchip Changes Into a Robot by Nicholas,
 Chapter Nine, page 134
City Plan by Edwin, Chapter Nine, page 133

Space Themes
Spaceman Attacking Big Monster by James,
 Chapter Three, page 43
Space by James, Chapter Nine, page 132

Drawings That Show Inside and Outside
A Dog Inside a Car by Judy, Chapter Three, page 44

Animals
Horse and Rider by Kate, Chapter Four, page 55
Australian Zoo by Thomas, Chapter Nine, page 127

Monsters and Dragons
King Kong by Byron, Chapter Four, page 54
Attacked by Sea Monsters by Laura, Chapter Four, page 52

Myths
Hercules Slaying the Hydra by Blake, Chapter Four, page 54
Attacking the Snake by David, Chapter Five, page 70
Neptune, God of the Seas by Sandra, Chapter Eight, page 105
A Girl That Could Change Into a Dolphin by Michael,
 Chapter Six, page 76

Teaching Strategies:
Chapter by Chapter

Drawing-as-Language: A Rationale

This book is devoted to the idea that children whether pre-literate, learning to read and write, or literate use drawing as a language and, in so doing, gain its intellectual and affective benefits. To support this contention, a working definition of language is helpful.

Asked to define language, *communication* is the usual, spontaneous first response. This is not surprising since oral communication is the most common use of language for all of us. But communication is the least important aspect of drawing-as-language. After all, when children have an urgent message to deliver, they don't draw a picture.

It is useful to review that, before communication is possible, *thought processes* must actively prepare the way. These may be fleeting and almost formless or they may evoke sentence fragments, isolated words, and flashes of imagery. And, the *nature of the situation* determines whether the thoughts are subjected to analysis, or tossed off without intellectual scrutiny. *Emotions*, such as anger, love, fear, and so on, are shaping influences. *Pace* and *style* are also variables. In a crisis, mental processes are rapid, and may result in verbal outbursts; writing an essay, on the other hand, requires a slow and deliberate performance.

Language: any symbolic system, coded or uncoded, which facilitates articulation, expression, and communication of perceptions, thoughts, and feelings.

In tracing the stimuli for language, it is clear that some mental activity operates far beneath conscious awareness (in the unconscious) while some takes place just below the surface (in the intuitive preconscious). Analysis, while not divorced from the deeper levels, engages the higher reaches of consciousness. This brings us much closer to the unique value of drawing as a language medium, that is, to language values not immediately connected with communication.

While undoubtedly important to the scope of language, *communication* alone simply does not explain the mental processes that make it possible. A word to encapsulate these primary structuring activities is *articulation*. What exactly is structured, what articulated, are, clearly, the perceptions, thoughts, and feelings identified as the raw material of language.

Another word, *expression*, helps to define language and calls upon various media of expression. Expression reflects the influence of a particular medium, whether words, drawings, musical notation, or dance patterns. Articulation and expression are by no means unrelated: in any use of language, articulation continues throughout the act, whether making a drawing, a musical composition, or a poem.

The two processes, articulation and expression, have different connotations. Articulation carries an aura of process and becoming. Expression connotes bringing out into the open, a finished product, or, as the psychologists might say, a projection. Note must also be taken of the shaping influence of individual media; each has its own unique formal language, each makes a different contribution.

What then of *communication*, the word initially found inadequate? It is safe to say that articulation and expression are personal activities, not primarily concerned with

communication, but most definitely concerned with mental development, mental health, and learning. Communication, on the other hand, involves the user with at least one other person. It is best defined perhaps as the *social function* of language.

As an expanded definition of language, we can now say that

> *Language is any symbolic system, coded or uncoded, which facilitates articulation, expression, and communication of perceptions, thoughts, and feelings. Articulation refers to the mental processes associated with language; expression refers to the shaping influences of the medium; communication is the social dimension of language.*

Figure 2.1 appeared in a local exhibition of child art and is a fine example of drawing-as-language. I met Zion and his parents at the opening and they told me how the drawing came into being. The occasion was a boat trip on his uncle's motor launch for a family picnic. At this point in his life, Zion was one of those children who draw almost daily, entirely on their own volition. We can see that the excursion was an exciting event; note the extended arms and happy faces of the travelers, the energetic movement of the birds, the "perfect day" suggested by puffy clouds and a larger-than-usual sun. When the picnic site was reached and the boat docked, Zion asked for the drawing materials which his mother had been careful to bring, found a quiet spot, and began drawing. When he finished, he showed it

Figure 2.1 *Boat Holiday* by Zion, age 6.

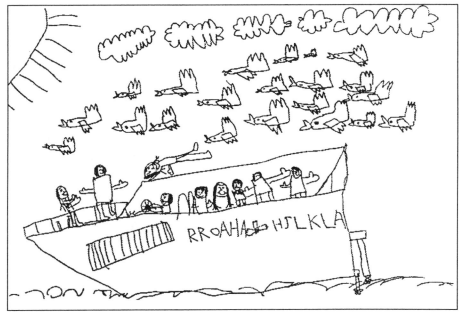

to his parents, and only then went off to play. There are extraordinary things about this drawing and we will return to it later. In this chapter we use it to show that children are using a language medium when they draw.

The Special Importance of Drawing-as-Language

When children draw, the mental functions are roughly those we would associate with words. Speaking, writing, and drawing (indeed, all symbol systems that combine *cognitive* and *affective* processes) are vital to mental development, learning, mental health, and the emergence of fully self-actualized persons. Each contributes in a unique way to the values of language. Each has its particular area of strength. Words, for example, are paramount in discursive and metaphoric expression, drawing in fostering empathic identification. Combined together, words and drawings offer an enriched learning resource.

Literacy is the ultimate goal of language education, but its acquisition depends on the mastery of several codes: codes for speech, printing, cursive writing, spelling, and reading. Only speech is a spontaneous achievement; the others require extensive teaching and learning.

While mastering the encoding and decoding skills of literacy, children benefit hugely from a language they can use to express their deepest thoughts and feelings. (Their drawings tell us that children are capable of such expressions.) Such subtle and complex thoughts and feelings are beyond the ability of children to express in words, yet they contribute much to mental development of the highest order. Drawing has the advantage of being uncoded, and is the most accessible language for this purpose. All children have a potential for using it, at least until the end of the primary grades.

We can say that drawing is the advance guard of literacy when it leads discussion and writing into thematic areas of expression not normally attempted with words.

Schema, the drawing equivalent of word
Schemata, the drawing equivalent of vocabulary

Some may not agree that drawing is a language, since it has no standard vocabulary and syntax. This is essentially true, but I am satisfied that when children draw, they use a visual vocabulary in syntactical ways. We'll stay with Zion's drawing to see how this is so.

Unlike the word 'gull,' Zion's drawing of a gull is a personal symbol or 'schema.' Children develop schemata as a graphic vocabulary for humans, animals, things, and environmental features. Schemata change as children gain experience and want images of greater specificity. They evolve towards using more detail (the principle of differentiation) and greater realism. For example, younger children may draw birds with the familiar 'V' but Zion wanted real birds with flapping wings and open beaks. His gulls are the equivalent of a number of words.

Zion's inventiveness is shown in his use of a complex form in twenty-one variations (figure 2.2). He might have pointed to the sky and said, "Look at the gulls

Figure 2.2 Variations on a schema for gulls in Zion's *Boat Holiday*. The birds have been traced by the author from the original drawing and taken out of context to show the subtle ways Zion varies his schema for gulls.

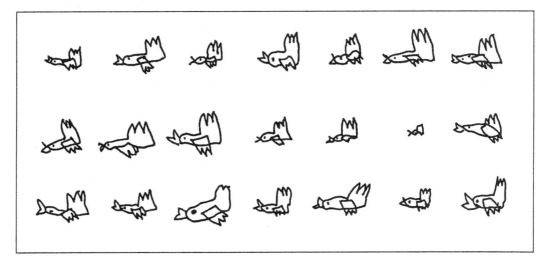

flying over the boat," words no sooner spoken than lost. But the drawing embodies many more formal relationships, creates a more vivid impression, and remains a lasting artifact. Schemata remind us of early pictographs whose abstract forms bear only a remote resemblance to their subject, but are still recognizable. It is interesting to remember that in China, pictographs evolved into a written language.

There are no adjectives or adverbs as such in drawing, yet the individuality of each of Zion's birds makes us think of modifiers. While he adheres to the basic schema, each gull is drawn slightly differently, suggesting adjectives, and each flies in a particular way, suggesting adverbs. The noun 'bird' requires modifiers to enrich it; in drawing, modifiers are implied by details.

Articulation and Expression— the Equivalent of Syntax

Figure 2.3 The birds in this detail retain their individuality, but compose a flock, an organized constellation of forms. Compare this to figure 2.2.

We have discussed articulation and expression in a general way and now look at it as the equivalent of syntax. The richness of language (words or drawings) is in the complex relationships of form to form and form to content. In this drawing (figure 2.3), syntax is found in the relationship of each bird to its neighbor, each to the flock as a whole, the shape of the flock to the shape of the boat, and so on. There is a repeated schema for bird, but it is not just bird, it is bird flying, bird in formation, bird screaming. While a single

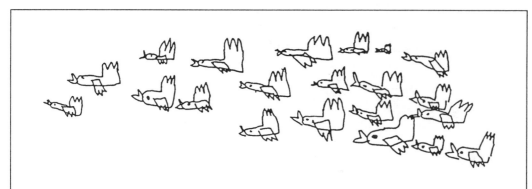

word can be expressive, with syntax words become literature. In Zion's drawing, the formal relationships in the flock of gulls imbue the drawing with poetic meaning and lifelike energy.

Limitations of drawing as a language medium

Words, because they are abstract and standardized, are the raw material of discursive prose and abstract ideas. Drawing can only illustrate, suggest, or symbolize, but this does not mean that it cannot be used to express complex and subtle thoughts and feelings. Young children are only beginning to need a language for abstract thinking, and drawing prepares a foundation for it. Zion drew his family in a special gathering and, without consciously intending to, showed the unity of the human family and nature. In later years, he might write an essay on this abstract topic; at six, his drawing creates a climate for later intellectual development.

Words have the power of poetic metaphor, but drawings have their own poetry and contain levels of aesthetic energy rarely matched in a child's verbal expression.

A focus on cognition

Through cognition, drawing transforms sense perceptions into images of symbolic meaning. A misguided theory would have us believe that all art is merely affective, nothing more. Drawings like Leo's *Santa* (figure 2.4) contradict this because each line of this complex image is the product of cognition and feeling, albeit at the level of the intuitive preconscious.

Figure 2.4 *Santa* by Leo, age 4.

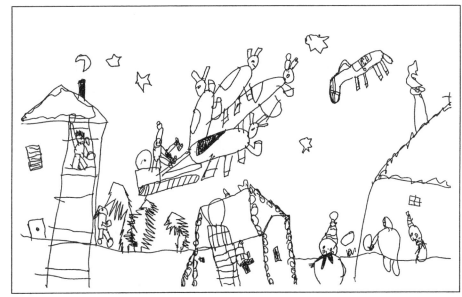

The genesis of children's drawing goes something like this: knowledge begins with perception; perceptions are stored in memory; memories, shaped by feeling, emotion, and imagination, are put on paper as semi-abstract forms.

A focus on perception and the senses

There are moments when we surrender to pure sensory experience; the warmth of the sun, the freshness of an ocean breeze, the view from a mountaintop, clouds against a sky, the green of young trees against a rocky slope. We find references to all of these in Denise's drawing, *Climbing a Mountain* (figure 2.5).

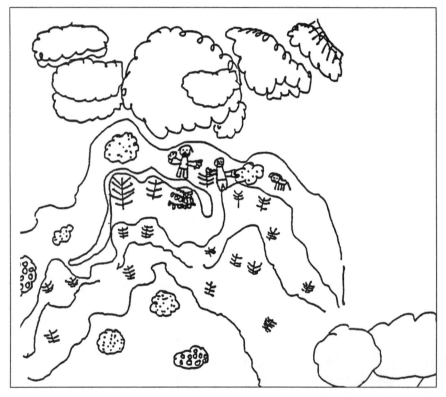

Figure 2.5 *Climbing a Mountain* by Denise, age 6.

Sensory awareness begins with the infant's experience of mother: her warmth, odor, sound, taste, and appearance. Soon, fresh air, sunlight, trees and flowers, the 'body of earthly delights,' are part of the daily experience. The feeling of unity with these two nurturing beings, mother and nature, is the beginning of aesthetic experience. It is not surprising that a child first draws mother, usually with a happy smile, or that early drawings frequently include a smiling sun.

In *Climbing a Mountain* we see two children, their arms spread wide, expressing happiness. Their dog is a short distance off. Mountain climbing is emotionally and physically satisfying, but it can also lead to intellectual

enquiry. Where do clouds come from and where do they go? Why is the sun warm? Why do things look small from up here? What are the different kinds of trees? Why do rocks fall? Although we begin with sensations and feelings, questions and ideas are never far behind.

Drawing as a Tool of the Intellect: To Capture Facts; To Order, Categorize, Compare and Evaluate Them

Michael's drawing (figure 2.6) is a celebration of nature and our need to establish a harmonious relationship with it. A stream flows through the forest. In it are three fish. The cycle of life is suggested by a gravel bed where a female has deposited eggs. Patterns on the fish differentiate male and female. An eagle successfully captures a meal and a native hunter tries to do the same. A raccoon hides behind a tree. There are thirteen trees belonging to four species. Trunks, limbs, leaves, and needles are added with careful attention to detail. Michael isn't old enough to perceive or remember that one tree blocks out another, or that many trees collectively take on the larger shape of the forest. His approach is like that of naives who draw every detail with meticulous care, not unlike the forests of the French painter, Henri Rousseau.

Figure 2.6 *The Forest* by Michael, age 8.

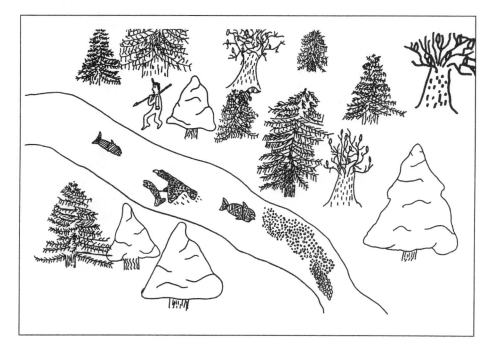

Children are interested in gathering information, making lists of facts and sorting them into categories, and in depicting the objects and events related to their lives. These are predominantly intellectual activities. Drawing also encourages empathic identification whereby children not only record what they know, but completely identify with it.

Drawing as metaphor

The Castle Shaped Like a Person (figure 2.7) suggests that Campbell was inspired by a fairy tale, although the story is his own. In a complex metaphor, castle and giant become one. Notice the stretched-out feet, the stairs rising out of the giant's lap, the building culminating in a head-tower with haunting eyes. When children draw metaphors, it is an indication of advanced thinking.

Figure 2.7 *The Castle Shaped Like a Person* by Campbell, age 5. Campbell's teacher printed the text on his drawing as he dictated it.

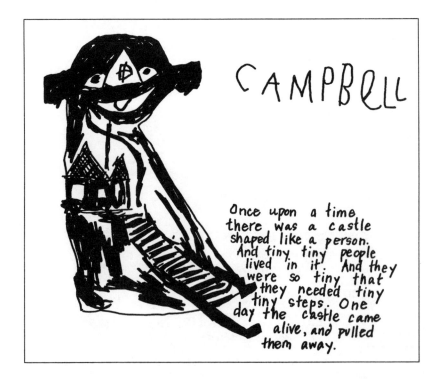

Once upon a time there was a castle shaped like a person. And tiny tiny people lived in it. And they were so tiny that they needed tiny tiny steps. One day the castle came alive, and pulled them away.

Drawing as invention

Nicholas likes to invent machines in his drawings. When he did this one (figure 2.8), he was living in a provincial park threatened by a mining development. Again there is a metaphor: 'mole' is a technical term for a piece of mining equipment; the animal mole is angry that the mechanical one is invading his territory.

Drawing as wit and humor

Was David caught in the middle of a family struggle, forced to choose sides, struggling with a moral issue? Or was he simply having fun with a graphic idea (figure 2.9)? David suffered from mild dyslexia and associated learning problems, but his drawings, particularly in their wit and humor, indicated a keen intelligence. Drawing can offer an alternative language for children who have problems with literacy and academic subjects. Social and psychological problems are frequently traced to learning problems. Children who are frustrated with the codes of literacy should be encouraged to express themselves graphically. (Nature often compensates with a special gift!) For these children, as for others, literacy is enhanced when drawing stimulates conversation, the use of words as captions and balloons, or the telling and writing of stories.

Wit and humor are signs of intelligence at play. David, because of his dyslexia, had difficulty with school subjects and consequently hated school. His marks tended to be below average and he was considered a slow learner. At the elementary school he attended, art consisted of craft projects that he considered "dumb" so, in the one subject that might have given him pleasure and esteem, his marks were never more than average. At home, however, he produced drawings daily, and many showed the kind of wit we find in *Caught In the Middle*. His parents believed this to be an indication of intelligence and emotional balance.

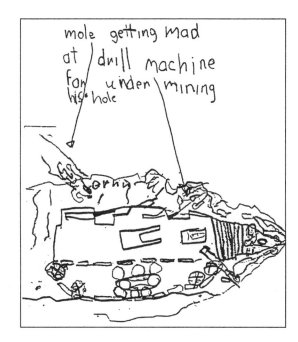

Figure 2.8 *Mole Getting Mad at Drill Machine* by Nicholas, age 10.

Figure 2.9 *Caught in the Middle* by David, age 9.

The Sea of Puns (figure 2.10) is meant to illustrate one eight-year-old's protean sense of humor. In this drawing all puns are related to the sea; there are fourteen other sheets in the series, each using a different locale or theme! Danny's teacher assured me that every figure in the drawing illustrates a pun. One or two of the more obvious: the swordfish dueling with the diver, the angel fish wearing a halo and carrying a star. Enlarged on a photocopier, this might be a drawing for class analysis. Apart from its humor, can there be any doubt about the intellectual activity demonstrated, or the intelligence of the boy who drew it?

Figure 2.10 *The Sea of Puns* by Danny, age 8.

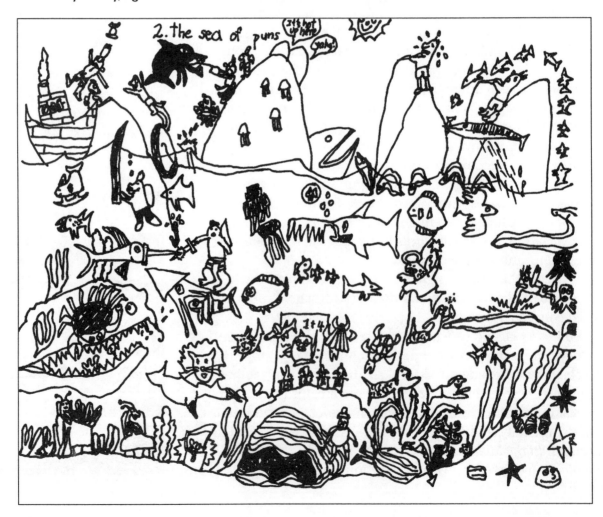

Through Drawing, Children Articulate Their Feelings and Emotions and Experience Catharsis

I have emphasized the cognitive and intellectual aspects of drawing because they have been sadly neglected by educational theorists and practicing teachers. Recognition of the cognitive and intellectual side of the arts, and their special ability to integrate the cognitive and affective, would revolutionize the home/school curriculum.

There is a danger in designating an entire class of subjects 'affective.' It is all too easy to overlook or downgrade an activity associated with emotions and feelings when the main thrust of education is said to be intellectual. In a social climate where emotional pressures are increasing for young people, we should not fail to recognize the significance of drawing to emotional health. Catharsis is one way this is accomplished. When they draw, children relieve the emotional tensions of negative situations. On the other hand, many celebrate life and give expression to positive emotions. While drawing will not solve problems of abuse, poverty, loss of companionship, or a multitude of other negative situations, it does provide a medium for sloughing-off negative feelings and diminishing overt aggression.

Drawing to relieve the tensions of sibling rivalry

The teacher asked the class to finish the sentence, 'I feel little when...' This response by Tyler (figure 2.11) is an x-ray drawing showing a house and its interior, and a sequence drawing, showing several stages of an event. It has intense emotional energy and we suspect that the drawer was both fascinated and repulsed by the physical needs of a new baby.

Figure 2.11 *I Feel Little When I Can't Change the Diapers* by Tyler, age 6.

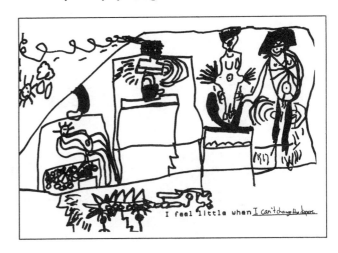

I feel little when I can't change the diapers.

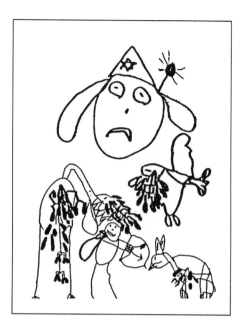

Figure 2.12 *God Above the Battle* by Tyler, age 6. Tyler told his teacher that the figure hovering over the battle was God.

Figure 2.13 *My Mom and Dad Screamed "YOU, YOU"*, anon.

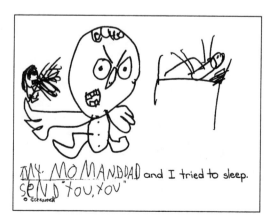

Drawing as religious feeling

I'm not sure that Tyler's drawing *God Above the Battle* (figure 2.12) is about religious feeling, but it is the only one in my collection which attempts to depict God. Children's drawings are often concerned with battles between good guys and bad guys. Here God is shown as an imposing head floating above the fray. He wears a cap with an electronic device for receiving and sending messages (this is Tyler's explanation). The warrior below appears to be happy as he draws blood from his attackers, but God looks worried and distracted.

Drawing as a vehicle of unintentioned communication

Some messages are projected from the deep unconscious and are clothed in obscure symbols; these require the interpretive skills of a psychologist. Others, like this one, are clear. The teacher's suggestion was to illustrate "what might keep you awake." While other kids drew dogs barking, and so on, this youngster depicted an argument (figure 2.13). Communication may have been the motivation, but more likely there was a need for catharsis.

Drawing as communication across language boundaries

Drawings can communicate across ethnic and national boundaries, creating bonds between children. Professor Jang Jingzhi of Beijing Teacher's College took her class to a farm village and asked them to draw the buildings that attracted them in as much detail as possible. Villagers also posed for them. The result was a collection of exquisite line drawings which, if studied by North American children, would reveal much about life in China (figures 2.14a and b).

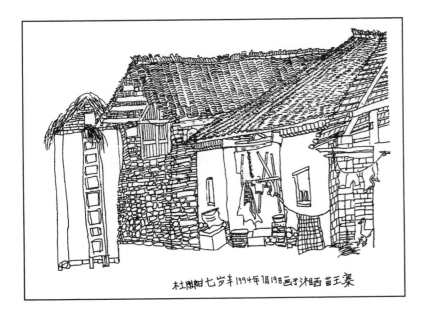

杜剛剛七岁半1994年1月19日画于湘西苗王寨

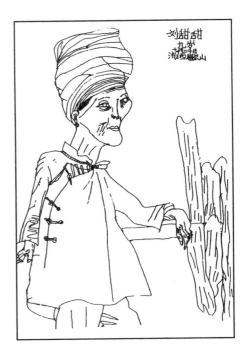

Figure 2.14a and b
Two drawings from
China by nine-year-olds
showing farm buildings
and a local farm woman.

Drawing to recapture events

A local art teacher took her students, their parents, and
grandparents, on a one-day drawing excursion to the com-
munity of Chemainus on Vancouver Island. It rained heavi-
ly, but everyone had brought an umbrella. They visited the
town's famous outdoor murals and the waterfront with its
fishing boats. An empty building was offered as a shelter so
the children could draw. By lunch time the children were
so caught up in their drawing that they declined an invita-
tion to accompany their parents to a restaurant. The day
ended with a ferry ride home and a banquet in Chinatown.

Norman's picture of the ferry boat is impressive (figure
2.15, see p.32). Fifty-three people were drawn, apparently
without hesitation! The bodies conform to a basic schema
but, like Zion's gulls, each face conveys individuality. This
is one of many drawings made when the excursion was
only a happy memory.

Drawing to facilitate social bonding

Drawing with friends. Drawing is a private activity but we should not overlook its usefulness for social bonding, particularly for intermediate age children. When older children get together to make drawings, their sessions are typically silent, but conversations break out periodically and results are compared. If one has a particular skill, he or she may engage in spontaneous peer teaching. Younger children can collaborate on drawings with family members.

Drawing on the same page. I once observed a father and his eight-year-old son at a noon-hour recital. The boy began to draw on the back of his program and, as it was Hallowe'en, his first figure was a witch. (By now the recital had begun.) The boy handed paper and pen to his father who drew an illusionistic box around the witch. The paper went back and forth, something added with each exchange. The father contributed background, drawing in a simple way so as not to outshine his son. Soon the boy settled into drawing by himself, and the father was able to enjoy the music without interruption. I later learned that this was a game the family frequently played.

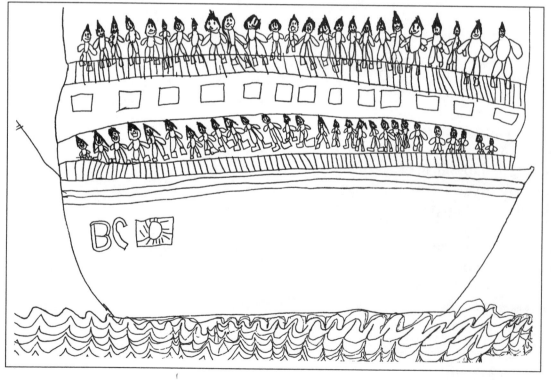

Figure 2.15 *Drawing Excursion On the BC Ferries* by Norman, age 5.

A Guide to Development: First Scribble to Mature Realism

Many books have influenced my teaching and writing, including those that deal with the developmental stages of children's drawings. Most important of these is Viktor Lowenfeld's classic textbook, *Creative and Mental Growth** used so long ago in my undergraduate art education seminar. More recently, *The Child's Creation of a Pictorial World***, by Claire Golumb, succeeds in bringing scholarship in this field up-to-date. But my greatest inspiration has come from the children and young people in my art classes, and from three children and four grandchildren of my own. It was through observing their art work over the years that I was able to see firsthand the developmental stages of child art.

Children begin by scribbling, but soon scribbles become representational abstractions, symbols of persons, things, and events. This is followed over the next few years by a consistent development, but unless encouragement occurs at home and school, it fades away in the late primary or early intermediate grades. In this chapter, we begin with *Random Scribble* by James, who was two, and end with *Oil Spill* by Samuel, who was sixteen. The first is

..

*New York: Macmillan, 1947.
**Los Angeles: University of California Press, 1992.

simply an initial exploration of materials, the second, a fine example of what I call 'empathic realism' (explained on page 35). Before beginning this journey, the following points need to be made

The Developmental Stages

The developmental stages of drawing vary from child to child. The developmental stages of any one child are most clearly seen when an opportunity is given for daily drawing and a selection of drawings is kept and studied. While each child goes through similar stages, it is not uncommon for some to skip a stage, or linger in one. The broad development is toward realism, but children take their own time and make personal detours. Most never arrive at a mature style for lack of practice and encouragement. When daily drawing is an integral part of the home/school curriculum, we may expect that all young people will reach the stage of mature empathic realism, just as all graduating students are able to write essays.

Knowing what the drawing stages are doesn't mean we should teach them in formal lessons. At the same time, it can only be enriching to set the stage for a natural unfolding. To motivate a first drawing on perspective, for example, we might proceed as follows. A primary class is taken for a neighbourhood walk up one side of the street and down the other. They are asked to pay particular attention to the street and the houses on either side. Back in the classroom, drawings are made. Some of the drawings are likely to be 'fold-overs,' that is, two rows of houses falling at right angles from a road in the centre of the page. This is a first attempt at solving a difficult problem in perspective.

Empathic Realism:
An Explanation

Older children are preoccupied with making their art look 'real.' This is understandable and must be respected, but realism is usually too narrowly defined. When the only goal is to replicate surface appearances ('naturalism'), other aspects of reality are ignored, nothing less than the full range of our emotions and the limitless potential of our intellectual life. Moreover, in 'naturalism' the processes of articulation and expression are severely limited, the very values we most want and should expect from drawing-as-language. There is need for a broader definition of realism to engage the interest and imagination of post-naives.

'Empathic realism' is art that has its roots in life experiences, but only when these have been transformed into aesthetic energy through empathy. Let me clarify my reasons for making the distinction between naturalism and empathic realism:

- Empathic realism is a broad term which excludes naturalism, its antithesis, as well as decorativeness and fantasy. While decorativeness and fantasy are not the same as empathic realism, they are valuable in other ways. Decorativeness is found abundantly in crafts, works by great artists (Henri Matisse), and in child art (Tony's monster figure, page 42). Fantasy is found in works by great artists (Hieronymus Bosch, William Blake), and in child art (James' *Spaceman Attacking Big Monster*, page 43).
- The usefulness of 'empathic realism' lies in its appeal for post-naives who are ensnared by the false value of 'naturalism'. I have found that young people are receptive to the broader definition, particularly if their need to draw with convincing realism is recognized and encouraged, rather than discouraged.

- Exemplary drawings of 'empathic realism' by young post-naives are found in this chapter: *Chinatown Banquet* (page 46); *My Family Playing Games* (page 46); and *Oil Spill* (page 47).
- 'Empathic realism' will be made more attractive to post-naives when works by great realists (Thomas Eakins, Edward Hopper) are shown to contain the same values.
- It may also be helpful to show that works not normally thought of as 'realistic' exemplify 'empathic realism'. *The Scream* by Edvard Munch, the Norwegian expressionist, or Picasso's drawings of athletes playing beach ball (described in Chapter Five) are examples. These are based on 'real life' experiences, and the expressive distortions and abstract forms we find in them are the result of profound empathy for the subject matter.

The Evolution of Children's Drawings

Drawing begins as random and exploratory scribbling and evolves into marks that are meaningful and affective. The so-called "stages of development" include the following.

Random scribbling appears first and evolves into linear and/or geometric shapes, sometimes, but not necessarily, meaningful. The first impulse is to explore materials in a playful way. Scribbling can also be a graphic translation of movement and sound such as a fire engine or a car crash.

Naming the scribble. The drawer recognizes and points to a familiar object found in a random scribble.

Schema/schemata. Geometric shapes are combined as persons, animals, plants, houses, and so on. A frequently

repeated configuration is called a 'schema'. Schemata are the 'words' of a graphic vocabulary. Combining schemata in story-telling compositions stimulates thought processes roughly parallel to syntax.

The 'tadpole' figure. The first human representations appear as head-body circles with facial features and extended limbs.

Base-lines indicate ground planes and environmental/spacial effects. They may be double, multiple, are generally straight but sometimes curved, and may reflect environmental conditions.

X-ray drawings show interiors and exteriors simultaneously.

Fold-over drawings solve difficult perspective problems such as people gathered around a table, or houses on both sides of a street.

Sequence drawings illustrate the several stages of a complex action.

Overall evolution of forms and themes from simple to complex; from frontal presentations to those showing depth and perspective; from the depiction of personal relationships ("My Mom") to complex stories based on real or imagined experiences; from symbolic abstraction to empathic realism. (For a definition and description of emphatic realism, see page 35.)

Figure 3.1 A random scribble by James, age 2.

Figure 3.2 A scribble with meaning by Danny, age 6, a bright but severely language handicapped boy.

Figure 3.3 Scribbled marks by Lawrence, age 3.

Examples of Children's Drawing Development

Scribbling

Scribbling begins as a playful exploration of materials, yet it is as important to drawing-as-language as babbling is to literacy. When an infant is strong enough to hold a crayon, scribbling gives two kinds of satisfaction: the kinesthetic pleasure of rhythmic body movement and the aesthetic pleasure of making and seeing marks and patterns.

Are young children just scribbling when they scribble?

Dr. John Mathew, a researcher at Goldsmith's College, London, found that children much younger than Danny use gestural marks in the normal scribbling stage to accompany action-filled daydreams. As Dr. Marion Porath wrote in Drawing Network Newsletter about Dr. Mathew's work: "Scribbling is seen as a meaningful activity which, along with other early attempts at symbolization, provide the 'building blocks' of future drawing development."

Lawrence's mother wrote: "...the almost three-year-old Lawrence is beginning to like scribbling. He once spent almost an hour enjoying himself with his pen. He's very active most of the time, but when he picks up his pen, he's very absorbed and he seems to really concentrate and like what he is doing."

Any non-representational mark can be thought of as a scribble, but scribbling has a developmental profile. It begins with the familiar tangle of lines, but soon dots, dashes, slashes, and zigzags appear. Order begins to emerge and random lines become geometric structures: diagonals, crosses, circles, oblongs, rectangles, crosses within circles, and so on. These are the basis for later

drawings of persons, animals, buildings, and objects. A vocabulary of scribbles, marks and shapes evolves, and the transition to representation begins. After this, scribbling is reserved for the occasional application of tone and texture for decorative and expressive purposes.

Here Lawrence drew a simple shape and attached a number of gestural lines to it (figure 3.4). Herbert Read pointed out the similarity between these configurations and mandalas, the symbol of wholeness in Indian and Tibetan iconography. They also relate to the sun found in so many drawings, and may be precursors of the 'tadpole' figure for humans.

In figure 3.5, we see Lawrence's drawing developing in two ways: he uses a greater variety of shapes and commands the whole space on the drawing sheet. Lawrence was not yet making deliberate representations, but his graphic language had evolved to the point where he soon would.

Naming the scribble

Representation begins when a child discovers unintended images of persons, things, and events in a tangle of scribbled lines. This is a common perceptual phenomenon. The ancient Greeks found the shapes of gods in the night sky; Leonardo imagined strange creatures in the patterns on stained walls. In art education parlance, it is called 'naming the scribble.' Two examples: a baby was playing with the porridge he had spilled on the tray of his high chair. Using his finger, he made a rough triangle and said to his mother, "Boat!" This puzzled her until she remembered that a sailboat was his favorite bathtub toy. A toddler was carried by her grandfather to admire a newly planted fruit tree bearing a single peach. The next morning she was scribbling and pointed excitedly to a circle, exclaiming, "Grandpa's peach!"

Figure 3.4 Circles with radiating lines by Lawrence, age 3.

Figure 3.5 Shapes by Lawrence, age 3.

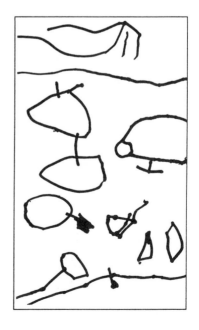

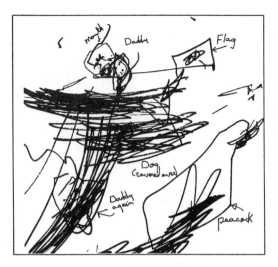

Figure 3.6 *The Peacock* by James, age 3. The words record the conversation after the drawing was finished.

The transition from scribble to representation

In *The Peacock* (figure 3.6), James made several attempts to draw his father. He began by creating a scribbled 'scarecrow' out of diagonals and arching horizontals. The first head didn't satisfy him so he superimposed a second. Father is waving a flag. A dog is scribbled over. In the lower right is a peacock. James was beginning to move from scribbles to representations and he loved to talk about it.

The tadpole

For most children, the 'tadpole' is the first image for the human form, consisting of a single ovoid or circle representing head and body, with radiating lines for arms and legs. In Michael's double figure drawing (figure 3.7), scribbling has been retained to give substance to the bodies and to represent hair. This is a portrait of Michael and his mother. From the way the larger figure envelopes the smaller, and the smaller touches the larger, we can infer a warm and positive relationship.

Tadpole figures are seldom done with such individuality and detail as Janika's (figure 3.8); they don't usually have teeth and such precisely drawn hair! It is interesting to speculate why, for most children, the first attempt at drawing humans makes no distinction between body and head. The form is not what they see when they look at humans, but is true to the way they experience their bodies. (Test this feeling by shutting your own eyes.) They draw what they feel and what they know. For young children, head/body with radiating limbs may be expressive of this somatic sensation.

Figure 3.7 Two 'tadpole' figures by Michael, age 3.

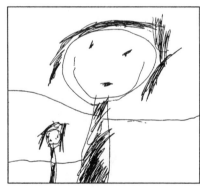

Figure 3.8 Two 'tadpole' figures with a printed text by Janika, age 3.

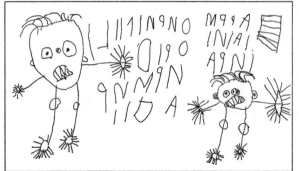

Gestalt psychologists offer another possible explanation. They see the circle as a primary form, easily conceptualized and drawn. They also point out that a principle of 'differentiation' guides image development, that is, as knowledge is gained, forms become more detailed. Children begin drawing humans with a head/body circle, but soon the head and body become separate forms, and details are added as marks for eyes, nose, and mouth.

In Janika's drawing, we wonder what motivated the intensity of the eyes, the fiercely grinning mouths, the electrically charged hair, and flailing arms? At an early age, she achieved an unusual degree of differentiation. Two figures share space with a banner-like array of letters and numbers. Was Janika articulating her excitement at being introduced to words, numbers, and graphic symbols?

In figures 3.9a and b, the shapes common to late scribbling have evolved into animals and letter forms. In *Moose*, two ambiguous 'Bs' double for legs. We can appreciate the aesthetic energy found in the way children make their first letters; we enjoy the quirky individuality of Geoffrey's word, 'fish.' As he gains control over his printing and as his words become more standardized, they will lose this charm.

Early empathic realism

Sometimes children tell a story by showing different segments on the same sheet. Frankie did this sequence drawing after his mother had been in the hospital having a baby (figure 3.10). He probably began by drawing his mother (in bed on the right). A nurse is in attendance, a professional smile on her face. He empathizes with the pain his mother felt, showing her body arched and tense. On the left, the baby is born and his mother is more relaxed. The nurse holds the new baby, her smile even broader!

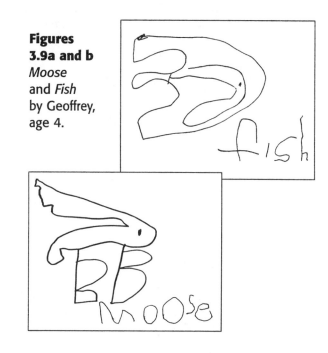

Figures 3.9a and b *Moose* and *Fish* by Geoffrey, age 4.

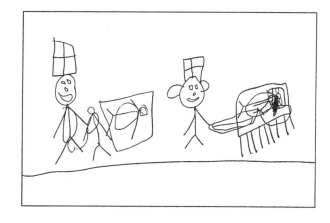

Figure 3.10 *Mother In the Hospital Having a Baby* by Frankie, age 3.

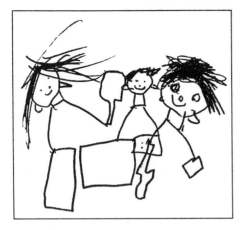

Figure 3.11 *Me Watching Mom and Dad Play Tennis* by James, age 5.

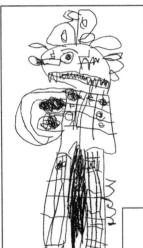

Figure 3.12 *Monster Drawing* by Tony, age 4.

Figure 3.13 *The Man Has Just Kissed the Woman* by David, age 6.

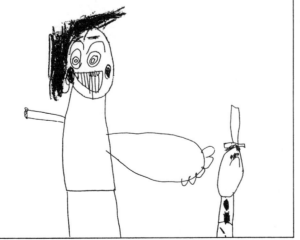

James celebrated a happy moment watching his mother and father playing tennis (figure 3.11). The drawing is another example of empathic realism, the child feeling a strong identification with subject matter.

Differentiation and decoration

Tony's monster (figure 3.12) is more complex than a basic tadpole figure and illustrates a different developmental direction, the elaboration of forms to achieve decorative pattern. At times, storytelling and representation may be abandoned altogether, and the drawer will concentrate on pattern and elaboration for its own sake. In my experience, this abandonment of story telling is a stage that some children enter for a brief time before resuming narrative drawing.

Size, a function of importance

Children draw selectively, according to their feelings, exaggerating and distorting forms that are of particular importance to them. In drawing a family, the mother may be largest if she is most important to the child, or the drawer small relative to others, either as a result of low self-esteem or because he feels small relative to adults. In David's drawing (figure 3.13), he has identified himself as the figure on the right (the 'man' in the top hat!) and the large figure on the left as his mother. He may have disguised his affection for his mom by attributing the kiss to someone else. The mother's arm pointing to David is much larger than her other one. Later on, size will indicate relative distance.

Base-lines

In the early stages of development, figures float in undifferentiated space. Soon children become interested in environments, people, and activities. They are faced with the problem of placing figures in space. The usual solution is to introduce a base-line on which important elements are placed like characters in a shooting gallery, forms rising at right-angles from the ground plane. The base-line can be curved to show a planet as in figure 3.14 or a round table as in figure 3.19 (page 45). If the story operates on multiple levels, as in James' battle scene (figure 3.15), two base-lines are used to indicate near and far. In his drawing of a hovercraft (figure 3.16), Michael's base-line shows ocean waves, and underneath one of the boats there is turbulence caused by its jet engines. The other boat is taking on passengers and is not yet in operation. This is an unusual example of a base-line showing environmental conditions.

The ubiquitous sun

The sun, with or without facial features, appears in most children's drawings of the outdoors. We might speculate on how children know that the sun is round and emits rays of light. Are suns copied from adult abstractions, or from coloring books or comics? Is the convention passed along from child to child? And why are suns usually in a corner of the picture? These questions are not easily answered. Since suns appear in drawings by both the gifted and not so gifted, there is probably no developmental significance. And yet they lend a cheerful ambience we would like to think reflects the child's state of mind.

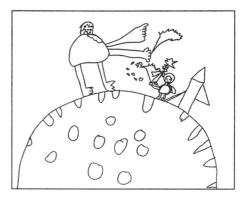

Figure 3.14 *Spaceman Attacking Big Monster* by James, age 7. The title was derived from a conversation with his mother when James finished drawing.

Figure 3.15 *Battle* by James, age 7, an example of a double base-line.

Figure 3.16 *Hovercraft* by Michael, age 5.

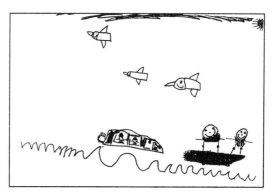

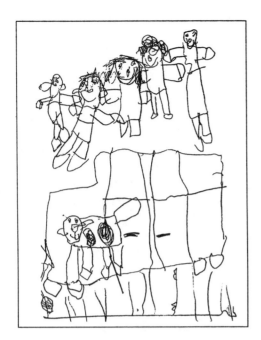

Figure 3.17 *A Dog Inside a Car* by Judy, age 6.

Figure 3.18 *Downhill Skiing* by John, age 11.

X-ray drawings

In figure 3.17, Judy's family is shown getting ready to go for a car ride. The dog has jumped in first and, even though he is inside the car, he can be seen clearly. This is an x-ray drawing.

A familiar saying is "Children draw what they know, not what they see." This is only partially true as it is inconsistent with the theory that knowledge begins with perception, although some knowledge comes from being told. (In a drawing showing both mother and unborn child, for example, knowledge does not come from perception.) The familiar saying could be amended to, "Children draw what they see, what they know, and what they feel." Primitive artists such as the Australian aborigines also use x-ray drawing. Unencumbered by concepts of literal naturalism, children and aborigines make vivid renderings of inside and outside, visible and invisible.

Sequence drawing

John captures the tragicomedy of this imagined event in his sequence drawing (figure 3.18). Three stages of a skier attempting a jump are shown: the confident beginning, the still-confident jump, and the final headfirst plunge into the snow! Note the connecting arrows which are intended to make us understand that we are looking at three views of one person, not three different skiers.

Developmental Stages So Far

We have reviewed children's drawings of figures floating in space, figures on single and double base-lines, figures inside and out. These lead to storytelling in pictures. Most drawings require a single image; other expand into several

frames like a comic strip. In sequence drawings, children divide the page into borderless episodes. The development continues.

Perspective: from fold-over to vanishing point in three stages

The drawings that follow show how three child artists solved problems in perspective.

Asked to draw what she liked best about a trip with her art class, Eileen drew the banquet they enjoyed at the end of the day (figure 3.19). The challenge was to draw twelve people seated around a table. Not yet concerned with linear perspective, nor able to handle it, Eileen solved the problem by making a fold-over drawing. As noted above, this is simply a special way of organizing forms on a baseline, here, a completely round one. Twelve children sit at a large round table covered with traditional delicacies and steaming bowls of rice. Each is carefully drawn with attention to gender, individual dress, and facial expression. (The intricate detail in this drawing contradicts the assumption that children have short attention spans.)

The fold-over drawing is a naive attempt to draw complex forms in perspective. This solution would not satisfy those who feel drawing should be photographically correct but, like x-ray and sequence drawings, it serves the child well for a time. Eileen was still young enough to feel empathic identification with her subject: if it feels right while being drawn, it will look right when finished. She kept turning the drawing as she drew each of the twelve people at her banquet table.

In figure 3.20, Andy has abandoned the fold-over approach and moved some distance toward linear perspective. He did this without formal instruction. Again, twelve people are seated around a table but are observed from a single point of view. The parallel vertical lines of the

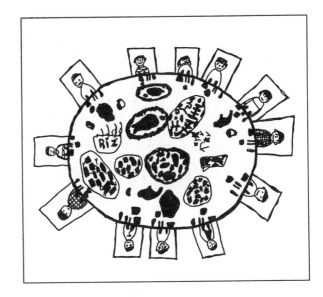

Figure 3.19 *Banquet* by Eileen, age 6.

Figure 3.20 *Family Christmas Feast* by Andy, age 10.

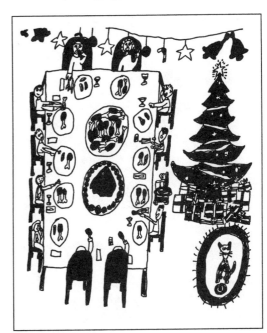

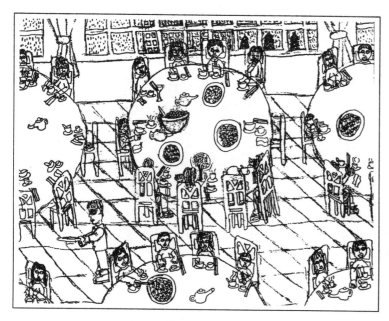

Figure 3.21 *Chinatown Banquet* by Caleb, age 8.

Figure 3.22 *My Family Playing Games* by Stefan, age 12.

table diverge slightly, contradicting the converging lines of 'correct' vanishing-point perspective. ('Reverse perspective' appears in medieval book illuminations and Persian miniatures, and is not thought to detract from their loveliness!) The drawing's most successful 'correct' perspective is the profile rendering of those seated at opposite sides of the table. On the other hand, some figures are viewed from floor level while the table is seen from above. The strength of Andy's formal composition and its expressiveness leave us unconcerned with these inconsistencies. There is even a possibility that 'improving' the perspective would weaken the drawing's formal and expressive qualities.

Caleb drew the same banquet that inspired Eileen (figure 3.21). It is a marvel of realistic perspective, considering that he was only eight.

A study of the three banquet drawings shows a development towards linear perspective consistent with the way we see objects in space. While the general direction is towards realism, development is individual, and not necessarily related to age. Eileen was six when she did her fold-over drawing; Andy was ten when he did his *Family Christmas Feast*; Caleb was only eight when he did his drawing and, in terms of perspective, his is the most sophisticated.

Mature empathic realism

Stefan is a strongly self-motivated drawer evolving gradually towards adult standards of realism, but he is still unable to solve the problems of perspective and tonal rendering entirely. In figure 3.22, his parents are sitting on the floor playing a board game. Their upper bodies are in profile and rela-

tively easy to draw, but their folded legs are beyond Stefan's ability. Stefan and his sister are in the foreground, but he has not drawn them using overlapping planes. The drawing was made from memory and imagination, not from direct observation. These minor weaknesses do not detract from the charming poetry of the image.

When Samuel drew this picture of an environmental disaster (figure 3.23), he was in an excellent secondary art program. Our journey through the developmental stages of children's drawings ends with this fine example of mature empathic realism.

Teaching Suggestions Related to the Developmental Stages

When children first recognize their potential for representing the people, things, and events that interest them, they begin a journey. Simple forms evolve into more complex forms. Early differentiation develops gradually into empathic realism, decoration, or both. Suggestions for encouraging this are reviewed as follows:

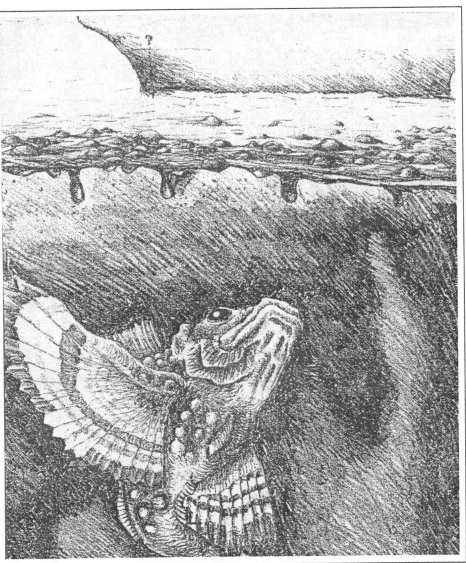

Fig. 3.23 *Oil Spill* by Samuel, age 16.

Motivate but don't instruct

Imagery evolves spontaneously when drawers are motivated. We should intervene only when students ask for help and this should be limited to motivational strategies such as telling stories, visualization, and guided imagery. Formulas and easy solutions inhibit intellectual growth by denying children the challenge of solving their own problems.

Set the stage for unfolding

Teachers can set the stage for x-ray, sequence, and fold-over drawings by choosing themes that stimulate their use. For example, stories which combine interiors and exteriors lead spontaneously to x-ray drawings. Analyzing events in stages encourages the use of sequence drawings. Describing family banquets or street scenes encourages the use of the fold-over technique. These are ways to expand a child's graphic vocabulary.

Help drawers to master perspective

As children progress through the stages of learning perspective (exemplified by the three banquet scenes) we should praise their ingenuity. If the drawer is unhappy with his or her progress, we can point out that achieving realism is a slow process of trial and error. Meanwhile, we can notice and praise the strategies that students use effectively. (Samuel, a sophisticated realist, used a technique much like an x-ray drawing to show tanker and fish in the same picture.) When reverse perspective appears naturally, as it did in Andy's banquet scene, his teacher praised him for providing more room for the table setting. If realism is the goal, we must always help the student work towards empathic realism.

Drawing For Mental Health

n the writing above Watts acknowledges that for individuals and societies there is an inevitable tension between the need for control and order on the one hand, and the need for spontaneity and freedom on the other. The question is, how do we find a balance?

The first goal of education is the mastery of the skills of literacy. This process involves discipline, rigidity, and order because codes must be systematically taught and conscientiously learned. At the same time, teachers try to encourage children to have a life-long passion for language, literature and writing. The great challenge for educators is to resolve these often opposite goals.

Unlike the skills of literacy, drawing, because it has no codes, is spontaneous. It can be motivated in many possible directions and used in a vast array of learning situations. We know that it aids the development of literacy. We can also say that it reduces the rigidity that Watts refers to. While refraining from making extravagant claims, we might reasonably expect drawing to have a beneficial effect on levels of "crime, insanity, and neurosis." Before going on, it is useful to make some general observations.

The child's education fosters rigidity but not spontaneity. In certain natures the conflict between social convention and repressed spontaneity is so violent that it manifests itself in crime, insanity, and neurosis which are the prices we pay for the otherwise undoubted benefits of order.

— *Alan Watts**

*The Way of Zen. New York: Vintage Books, 1957.

49

- Mental health is nurtured when we have a balance of intellectual and affective learning throughout the curriculum.
- The traditional curriculum limits language to words and numbers, creating an imbalance. Accepting drawing as a language medium would contribute to restoring balance.
- The arts have been incorrectly assigned to the 'affective domain' by some educational theorists, making them less important to learning. In reality, they are as much cognitive as affective and are beneficial to perception, intellect, memory, imagination, and judgment.
- The arts are the only subjects that integrate intellectual and affective modes of learning. Learning is known to be enhanced when charged with appropriate emotional energies.

Drawing as Catharsis

Figure 4.1 *I Hate Spakings* [spankings] by Marne, age 5.

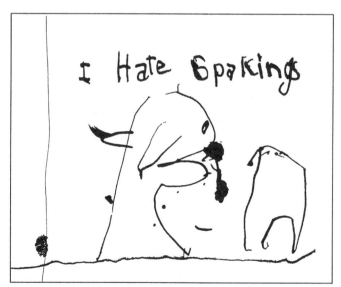

Catharsis: ...in psychiatry, the alleviation of fears, problems, and complexes by bringing them to consciousness and giving them expression.

As I write, I often hear young voices drifting through the open window. From time to time the stillness is broken by shouts of happiness, conspiratorial whispers, friendly chatter, the sounds of disappointment, rage, jealousy, and affection. An emotional aura surrounds children, forever shifting in tone but never entirely dispersing. When children draw, it is these feelings that are being expressed. It is the unique power of art to fuse thought and emotion in a single image, and it is this that leads to catharsis and healing.

Some drawings are charged with electricity and are immediately cathartic. When children are battered by emotional storms, drawing can provide an opportunity to restore balance. Healing is not necessarily immediate, as other influences come into play, but when drawing is encouraged by a caring adult over a period of time, healing may occur. A letter to the Drawing Network reinforces this point. "My seven-year-old daughter came home from school complaining of a stomach-ache. After a wee cuddle she said, 'I think I need to do some art. Do you ever feel sick, Mom, when you haven't done any art for a long time?' She proceeded to her room, created a drawing or two, and regained her sense of self and good health."

Marne's parent was provoked into giving her a spanking and she was sent to her room. *I Hate Spakings* (figure 4.1) is the drawing she made to discharge her anger and frustration during the cooling-off period. Marne, now an adult, suggests that her role as an outraged child was projected to her large toy rabbit, explaining the large ears of the central figure. Words and image combined to satisfy her need for language expression and catharsis. In figures 4.2a and b, with a few simple lines, Geoffrey was able to express contrasting emotions: love for his mother and frustration with his older brother.

Figure 4.2a and b
To Mom and *Mad at James* by Geoffrey, age 5.

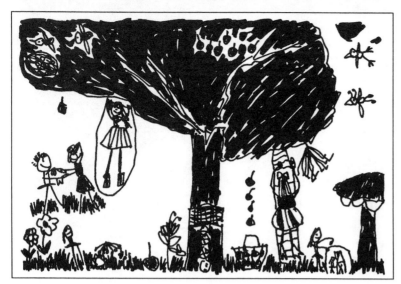

Figure 4.3 *The Apple Tree* by Laura, age 5.

Figure 4.4 *Attacked by Sea Monsters* by Laura, age 5.

Figure 4.5 *You I'm Going To Kill* by an unknown boy, age 8.

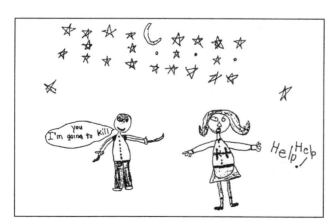

Laura's parents spend a lot of time playing with their children and reading to them and in so doing, provide them with sources of inspiration. Laura draws every day, and her images usually reflect the positive emotional climate of her home. *The Apple Tree* (figure 4.3) is her version of paradise, a picture of children playing harmoniously in a natural environment.

Another of Laura's drawings shows us that children are never without some fears, however secure and loving the family. *Attacked by Sea Monsters* (figure 4.4) depicts a terrifying nightmare, or perhaps a daydream. Its forms are more powerful, and its aesthetic qualities more impressive than those in *The Apple Tree*. In this drawing, emotional intensity seems to have driven form and content towards integration and catharsis.

There is a story worth telling to illustrate catharsis. Nonie Mulcaster was a distinguished art educator in Saskatoon when I was at university. In a seminar, she recalled her days as a young teacher in rural Saskatchewan. She was approached for help by the mother of one of her students, a child suffering from nightmares, sleeplessness, and bed-wetting. Some of the older children had frightened her with ghost stories and she couldn't get ghosts out of her mind when she went to bed. Over a few weeks, Nonie spent extra time with her after school, and together they talked about and made drawings of ghosts. Before long, ghosts had become friends and the symptoms disappeared.

Catharsis is most evident when forms are integrated and show aesthetic energy. There is no evidence of aesthetic energy in *You I'm Going To Kill* (figure 4.5), drawn by an unknown boy. It could be dismissed as a show of bravado, or it may have been motivated by violent stories, video games, or television. Still, drawings of undisguised aggression, particularly when they carry sexual overtones or are directed at visible or helpless minorities, should not be passed off as harmless. This drawing, unusually set at night rather than daytime, has a sustained hypnotic effect, with its stereotyped elements and compulsive repetition. There is something about it that should alert us. While not jumping to conclusions, wise parents and teachers will watch for signs of sociopathic behavior when there is a sustained, consistent pattern of violence in drawings.

Masked figures as part of Hallowe'en are a great lark for older children, but may be terrifying for little ones. Figure 4.6 is interesting because it shows several stages of image development. Beth draws herself as a scribble but the Frankenstein figure, the mask that frightened her (lower right), is drawn more realistically.

Caged Dog (figure 4.7) is astonishing in its precocious realism. The drawer was in a kindergarten class which had just returned from a visit to the local pound. Just as fright moved Beth's graphic imagery toward realism, so did sympathy move the drawer of *Caged Dog*.

Like many boys, David had a love/hate fascination with war and was attracted more to the antihero than the hero. His drawing (figure 4.8) shows a vehicle decorated like a hippie van and armed with an empty revolver ('click click'). It faces a menacing tank, heavily gunned. The base-line of this witty and fatalistic encounter is the outline of a nuclear cloud. Wit and humor are powerful agents of catharsis!

Figure 4.6 *Hallowe'en Drawing* by Beth, age 4.

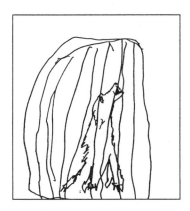

Figure 4.7 *Caged Dog* by a kindergarten child.

Figure 4.8 *Click Click - What the Hell* by David, age 9.

Figure 4.9
King Kong
by Byron, age 9.

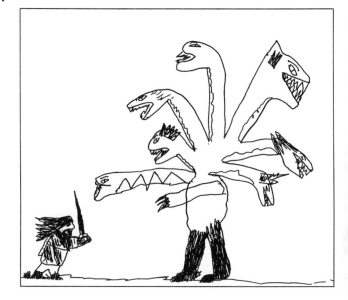

Figure 4.10
Hercules
Slaying the Hydra
by Blake, age 10.

Figure 4.11 *Love*
by Brandon, age 7.

Along with images of war, monsters are common in the drawings of young boys. This could be attributed to the influence of comics and television cartoons. The media shape children's tastes and, at the same time, cleverly cater to them by creating images that satisfy their psychological needs. As well, part of the appeal lies in the powerlessness a child feels, and the satisfaction of imagining oneself a King Kong or Hercules (figures 4.9 and 4.10). We are all concerned about the effects of television violence, but drawing monsters may offer therapeutic benefits for some children.

Brandon's amusingly erotic drawing shows couples kissing in the foliage of a tree (figure 4.11). Even the sun is kissed by a cloud! His obvious sincerity and thoroughness suggest that this drawing is not just youthful goofiness, but an engaging image of human love.

In response to her teacher's suggestion, "...draw what you yearn for more than anything else," Kate drew herself riding her dream horse (figure 4.12). If monsters and war are favorite themes for boys, horses are for pre-adolescent girls. The horse has no rival among mytho-poetic beasts; they can transport us to places of romance, danger, and heroic adventure. Kate has included an exquisitely drawn tree, in Jungian terms a symbol of the lifeforce.

Soccer, Hockey, and *Baseball* (figures 4.13a-c) celebrate the precept a healthy mind in a healthy body.' Sports activities can be opportunities to work off aggression; drawing them can serve the same purpose.

Figure 4.12 *Horse and Rider* by Kate, age 11.

Figures 4.13a–c *Soccer, Hockey*, and *Baseball* by three boys, age 10.

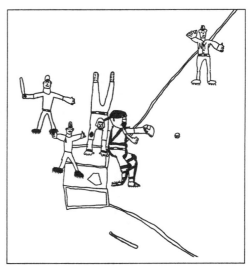

Drawing in the life of a six-year-old with a severe language deficit

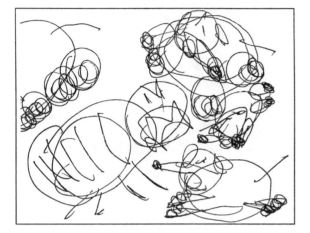

Figure 4.14 *Lion Drawing* by Danny, age 6, a child with a severe language handicap

Danny's father wrote, "This picture (figure 4.14) is part of a series (see also figure 3.2, page 38), each one operating as a panel in a story. The story involves lions (including a smaller baby lion with a mane), tigers, and elephants. There is a fight and resolution of sorts, with a lot of sad animals at the end of it."

While the stages of development occur at approximately the same age for most children, there are wide divergencies. At six, Danny was still scribbling, although his marks were far more expressive than those of a younger child. If you look closely, you can see that he used a kind of 'gesture' drawing to depict the protagonists.

Danny's father continued, "Danny's trouble was the failure of a frontal lobe cross-over between the two hemispheres of the brain. This was underlined by an inability to see and draw asymmetrical things. Danny would force a symmetry onto asymmetrical objects in his drawings, and also complete his graphic work using the same basic shape, usually circles. Danny has overcome this in some natural way known only to himself. Suddenly one day there were square windows instead of round ones on the bus."

While Danny's drawings might appear to be scribbles to most observers, they were actually charged with meaning. In the same letter his father continued, "Danny wants his drawings to be specifically understood, to function as an actual language. I am doing my best to reinforce this... they are stories, not just representations. Danny will discover the details of an object or animal and then throw them away for the sake of speed or facility."

Danny's drawing output is prodigious and reflects the frustration he feels at not being able to think and communicate effectively with words. His father again, "The sheer

volume of Danny's drawing is somehow relevant. I've kept the complete works of this or that session. It is hard to comprehend twenty or thirty drawings getting done in a seemingly effortless way in an hour. Danny likes to draw for about an hour when he comes home from school."

And in another letter, "I'm mostly impressed with the people and animals in Danny's drawings, also the sequence of events and that the drawings are built one on the other. (They are all naturally 'event' based). The thing that concerns me most is that the objects are getting more symbolic and complex, and while this is a very positive thing, it is important for me to understand just what he is saying. As he abstracts things more and more, they serve as icons to him (his tow-trucks no longer look like tow-trucks but are sort of an abstracted visual shorthand.)"

Recently, I talked with Danny's father on the telephone. Danny is now fourteen and in high school. He's in a regular class, sometimes accompanied by a teacher's aide. He still has a language problem, but it is gradually improving. His marks are average in academic subjects and, as we would expect, he does very well in art. He is a happy adolescent with a growing sense of himself. His father laughed when he told me that Danny had refused his parent's request for a self-portrait he had drawn. They saw this as an indication of his growing self-assurance and independence.

Catharsis in the life of an abused child

In a lecture given by Dr. Eleanor Irwin at the University of Victoria, she talked about how catharsis helped an abused child in her care. She was a therapist in a residential school for disturbed children. Her approach to healing was based on giving children the opportunity to project their feelings through play, drama, painting, drawing, puppetry, and film.

She began with a slide projection of one child's painting. It appeared to be an abstract expressionist canvas

gone seriously wrong, a muddy paste of blended yellows and browns. There was a pause as she gave her audience an opportunity to consider the image: she seemed to be asking, "...what do you make of that?" It had been painted by a severely abused and emotionally disturbed boy — we will call him Richard — who suffered from withdrawal, bed-wetting, and stuttering. She began the therapy by providing Richard with paints and paper which he was encouraged to use in any way he wished. Without being told to, or giving it much thought, he painted a series of images one on top of the other, even though there was no shortage of paper. A new episode appeared each day.

The first painting was a crude humanoid figure which he brushed on while muttering, "...here is a little boy who wets his bed." The next in the series was painted over the first: "...this is the daddy who spanks the little boy for wetting his bed." A third followed with a louder voice exclaiming, "...this is a monster that eats the daddy up!"

Over the next few days, Dr. Irwin came to Richard's side just before he was finished. Instead of allowing him to continue painting, she worked with him to make puppets, one for the little boy, one for the daddy, and one for the monster. A puppet show was put together which the other children were invited to watch. Richard, the loner, was gradually introduced into the society of his peers. Still later, the children wrote and produced a film about a mean daddy and the monster who devoured him. Richard played the leading role of the little boy.

Dr. Irwin was asked, "Did the therapy work?" She replied: "Not entirely. Richard wasn't cured, but he was much improved. After a few weeks his bed-wetting stopped, his stuttering improved and, previously a loner, he was making friends in the school community."

Felicitas and Ryan, young people with hearing problems

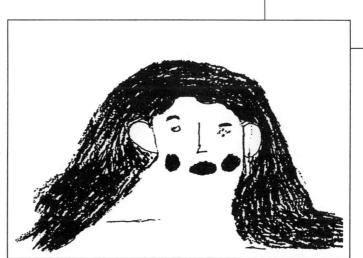

The Drawing Network had a letter from a resource teacher in Vancouver which speaks eloquently of the importance of art to physically and mentally disadvantaged children. "For the past nine years, I have been teaching deaf students in Mexico, Montreal, and Vancouver. For all children, drawing is an excellent means of self-expression, but for children with language deficits, it plays an even more important role. The students I taught in Mexico were mostly adolescents with no previous education and very few signing skills. Unable to use language to tell about themselves, their drawings became a valuable source of information. Felicitas entered school extremely shy and fearful of trying anything new. Her drawings became more relaxed, and by the end of one year, her self-portrait portrayed a smiling, calm face (figure 4.15b)."

Figures 4.15a and b
Two self-portraits by Felicitas, age 15 and 18.

"More recently," the Vancouver teacher continued, "I have been teaching art classes at Jericho Hill School for the Deaf. It has been an exciting experience to watch the students at work. Ryan is deaf-blind with a narrow line of vision in the corner of his eyes. In order to see his work, his nose touches the paper and he often finishes with paint or pencil on his face. He also communicates through sign language, but his skills are involved in his art projects: drawing, collage, and ceramics. Over the year, he has begun to interact more with the other students who admire his talents. Ryan draws daily in his journal and sketch pad,

Ryan As an Infant

illustrating his activities and exploring the use of shapes and color. He often fills an entire page with detailed shapes, colored in afterward so that every bit of the page is covered. A series of self-portraits depicts himself in infancy, childhood, and adulthood (figures 4.16a-d)."

"As a teacher of the deaf, helping my students develop communication skills is the main focus of my job. Drawing has been a wonderful medium for expressing emotions and experiences, enhancing self-concept, and providing a meaningful focus for conversation."

Ryan Now

Figures 4.16a–d Four self portraits by Ryan.

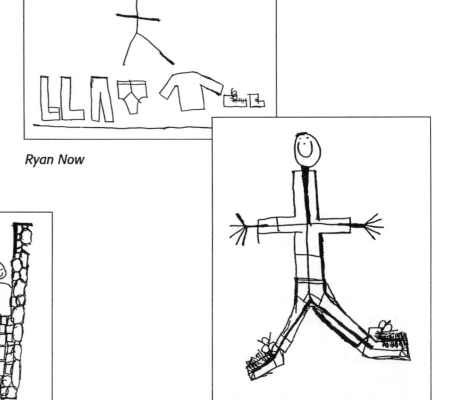

Ryan as a Young Boy

Ryan In The Future

oward Gardner, in his book *Artful Scribbles,** wrote: "Pablo Picasso poured over drawings by children and eventually published a set of sketches based on youngsters' renditions of the bullfight." Other 20th century artists, notably Paul Klee, Joan Miro, and Jean Dubuffet, did not hesitate to say that child art had influenced them, but we can be sure that they did not consider it the equal of their own. Indeed, Gardner quotes Klee, "Don't translate my works to those of children...they are worlds apart. Never forget the child knows nothing of art."

Although we acknowledge the vast differences between a work of child art and that of a 20th century master, we sometimes mistakenly dismiss the similarities as insignificant. Howard Gardner is tentative: "In striving for realism, he [the child] achieves charming, recognizable deviations from a photographic likeness...those of us who have tired of high realism and who have learned that deviations exert their own charm, find ourselves strongly and legitimately attracted to these rougher youthful products." But there is an attractiveness in child art even for those of us who never tire of high realism. The explanation lies, I think, in the 'aesthetic energy' found in both child art and modern art.

.......................................

*New York: Basic Books, 1980.

Child Art: The Aesthetics, the Significance, and What to Look For

I used to draw like Raphael; it has taken me a whole lifetime to learn to draw like a child.
— *paraphrase of a statement attributed to Pablo Picasso*

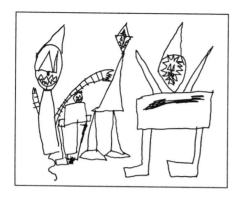

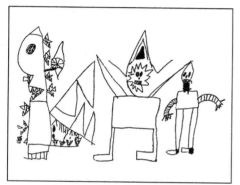

Figures 5.1a–c *Strange Monsters*
Three drawings by Geoffrey, age 6.

Studying children's drawings, I arrived at a theory of aesthetic energy, a term I find useful to describe some 'child art.' I define the term as follows.

Aesthetic energy: the radiant feeling of articulation and wholeness within a work of art resulting from authentic content, formal relationships, and the integration of form and content. When aesthetic energy permeates a work, it reaches the status of 'art'.

When aesthetic energy is present in drawings, there is a level of articulation and an expression of experience conducive to both learning and mental health. The material in this chapter illustrates the theory of aesthetic energy.

Picasso and Geoffrey

When Geoffrey was six, he gave me three drawings he had done in one day (figures 5.1a–c). Shortly thereafter, I came across the Picasso shown in figure 5.3. I was immediately struck by certain similarities but, of course, there were profound differences. If Picasso meant us to take him seriously about child art and its influence on him, perhaps we could profit from a comparative study of the two and, hopefully, throw light on the subject of children's art.

Both sets are in threes. Geoffrey's are on three separate sheets, Picasso's in three casually drawn boxes on the same sheet. All are rendered in classical line. Geoffrey's are done with the innocent bravura natural to children, Picasso's are energized by the touch of a master, but, one would judge, a master making a preliminary study.

Subject matter and content are poles apart. Geoffrey draws an ominous cast of characters, monsters from a fantasy world. Picasso's subject is young athletes playing beach ball. The sets are alike in their intensity of feeling, sense of empathic identification, and in evoking a strong

'presence.' Both rely heavily on flatness. Geoffrey, unaware of any other way, drew consistently in line and shape; Picasso chose line and shape from an extensive repertoire of techniques over which he had complete mastery. A comparison of shape quality reveals the limitations of the child compared to the master. Geoffrey made his figures of simple building blocks, rectangles and triangles, put together with impressive results for one his age. Picasso threw caution to the wind and invented a vocabulary of wild, exaggerated forms to serve his purpose. His shapes are not only attractive as abstract forms, but capture in their erratic outlines the distortion of violent movement.

Geoffrey shows his characters lined up as though they were taking a final curtain call. Flatness is unrelieved; there is no space. Picasso, in spite of unmodelled flatness, creates space by pushing his forms away from us. Huge bodies culminating in absurdly small heads. The effect is an empathic tension between the frontal plane and the illusion of depth, a tension which involves us in the physical action of the game. Imagine watching beach ball while lying nearby in the sand. Bodies will appear distorted because some parts are farther off than others. In real situations, we don't see this distortion because of the psychological principle of 'constancy;' our knowledge of body proportion cancels out fleeting optical impressions. The camera, on the other hand, catches and records distortions mechanically. In this drawing, we feel the `rightness' of distortion in much the same way a child feels right about his crude representations.

Geoffrey is not an artist in the same sense as Picasso, yet he makes art in basically the same way, by articulating and expressing his perceptions, thoughts, and feelings. For children, this process would be almost entirely intuitive, for Picasso, a mixture of intuition and intellect. As Klee pointed out, the child makes art but doesn't know that he

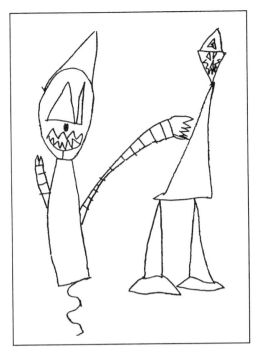

Figure 5.2 Detail from
Strange Monsters (figure 5.1a).

Figure 5.3 Pablo Picasso sketch
as copied by the author.

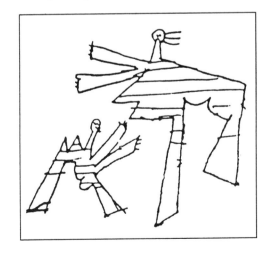

does. Moreover, the mature adult works from a vastly larger and more diverse background of experience. The similarities originate, I suggest, in the intense empathy which child and artist experience when making art.

Looking at Pictures

In looking at pictures, we should consider two dimensions: first, subject matter and content, and second, form (lines, shapes, colors, tones and textures).

Subject matter and content

Subject matter is the topic or theme of a picture. Content is the perceptions, thoughts, and feelings inspired by the topic or theme, embodied in the drawing, radiating back to the receptive viewer.

A Drawing Network correspondent described how he gave his class the opportunity to draw daffodils and caused me to reflect on how my elementary teacher appraoched the same topic. Together they illustrate the difference between subject matter and content. He wrote about taking children to visit a park in spring "...to see fields of daffodils ...to experience the open field, the sunshine, the flowers in their natural setting." They were were invited to examine the daffodils through a magnifying glass. The subject of their drawings that day was simply 'daffodils' but the content was much richer: the atmosphere of the park, the sunny day, the color and smells, the camaraderie and so on. In contrast, I remember being asked to copy a formula daffodil done on the blackboard by my teacher. There was no daffodil; in fact, I had never seen one. I dutifully produced the subject matter, but my drawing had no content.

The elements and principles of design

There are elements of design and principles that energize them. The elements of design (the form) are lines, shapes, colors, tones and textures, the building blocks of visual art. The principles of design are the ways the elements are organized in various relationships: similarity, proximity, alignment, gradation, contrast, tension, positive and negative shapes, and so on. The integration of these various elements as pictorial unity is of overriding importance.

Teaching

In recent years, 'elements and principles' have been taught as separate components of design. For example, lessons are organized around the element of shape, or the principle of rhythm. This is referred to as "learning the grammar of art," but it has little to do with language as we have been discussing it because it focuses on form and ignores content. In one popular exercise, children are asked to let a moving line fall back on itself to create shape and pattern. When a design of loops and swirls has been established, the shapes are filled in with color. While each product is unique, all are monotonously the same. This is called 'taking a line for a walk,' ironically, a title taken from Paul Klee's notebooks. The project is time-consuming, muscle-exhausting (for young children) and essentially boring. The finished products lack aesthetic energy because forms have not been made with empathy and do not embody content.

It is simpler, more fun, and more effective to teach the elements and principles of design through subject matter and content. They can be introduced gradually as children begin to show an interest in making their pictures better. The principles of design, when they express content, are sources of aesthetic energy.

Quality of line

Encourage a 'classical' line, a quality of line that suggests vitality, rightness, and expressive purpose (in other words, plain, clear, confident lines). This usually comes naturally to children. For teaching purposes, examples can be found in reproductions of early Greek vases, Picasso etchings, or the drawings in this book. The drawing game described in Chapter Seven suggests one way to introduce it. Because they are experiencing uncertainty, some children use a 'shaggy' line (usually lightly drawn, stop-and-start, tentative) to approximate forms. They should be encouraged to have faith in their ability to use line clearly to draw the shapes that will become the subject matter and content of their drawing. (Obviously, with older children, a variety of approaches is acceptable, including occasional use of shaggy, impressionistic lines. For example, if they are studying the impressionist school of painting, shaggy lines may be appropriate as part of the study.)

Quality of shape

Encourage the use of shapes that are derived from observation, or imagination. Shapes are made when lines define an enclosed space. The characteristic of strong shapes is that they appear to be supported from within by an invisible scaffolding, or the pressure of interior forces like air in a balloon. (Reproductions of Matisse cutouts are not difficult to find and are useful in teaching shape.) As a child's drawing progresses, various shapes begin to express the form of the work.

Forms that express content

The use of forms that express content should be encouraged. Forms can be decorative, but not merely decorative, that is, they must have intellectual and emotional signifi-

cance. A good example is found in the way Zion intuitively echoed the shape of his boat in the shape of his flock of birds. This will be discussed later in the chapter.

Repetition

Repetition is the repeated use of lines, shapes, and colors. Elements are put together in patterns. We respond to the repetition of visual forms as we do to the rhythms of music, or the cadences of poetry.

Alignment and tension

The alignment of elements within the picture plane creates integration or formal unity: shapes calling across to similar shapes, colors to similar colors, tones to similar tones. Alignment also creates tension, the tension of potential energy, like a stretched elastic band. We see alignment in how the sunbather lines up with the flock of birds in *Boat Holiday*.

Positive and negative form

Picasso's sketch of athletes (figure 5.3) is a good example of the relationship of positive to negative form. The contorted figures create positive shapes. Defined by the same edges or lines, the negative (empty) spaces become shapes as well. Aesthetic energy results from their interplay.

Diversity in unity

We experience aesthetic energy when diverse forms are integrated, and the disparate elements of a picture become a unity. Two conditions must be satisfied: first, nothing can be added and nothing taken away without destroying a delicate balance, and second, formal elements are in a state of dynamic tension, encouraging movement without risking disintegration.

All Drawings by Children are Language Expressions. *Most* Drawings by Children Radiate Aesthetic Energy. *Some* Drawings by Children Have Attained the Status of Art

My approach to the analysis of child art is much the same as to adult art, with one exception; even when there are low levels of aesthetic energy, child art is still valuable to the drawer's mental development. To better understand aesthetic energy and the status of art, I will analyze three drawings by children as though they were works by adult artists and will show that they are so resplendent with aesthetic energy that it is possible to call them works of art.

Figure 5.4 *Boat Holiday* by Zion, age 6.

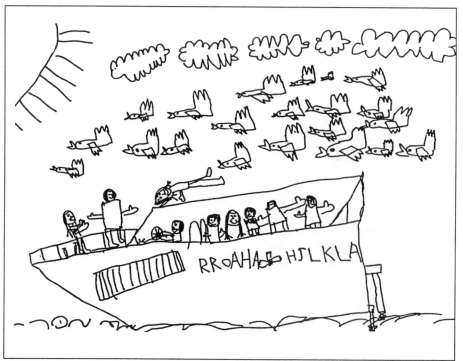

An analysis of Boat Holiday

Earlier we used *Boat Holiday* (figure 5.4) to illustrate the way schemata are invented and used in the intuitive way one would use vocabulary and syntax. In studying Zion's flock of birds in search of aesthetic energy, we see that a gull is a single unit, but that together they are a constellation of inter-related movements and tensions. The flock of birds as a whole is a shape made of

smaller shapes, individual birds composed of still smaller shapes.

In a remarkable example of the 'hidden order of art,' Zion has shown the oneness he felt with his family on this occasion, and the harmony they were all experiencing with the natural environment. He has done this in two ways: first, he has echoed the shape of the boat in the shape of the flock, two wedge forms cutting the sea air, one a closed monolith, the other an open network (figure 5.5). Of course, as a six-year-old he could not possibly have planned it this way; it must have been done intuitively. The second relationship reinforces the first. The sunbather, lying on the deck, creates a diagonal line which joins the upper and lower halves of the composition (figure 5.6). She serves another function: her body pulls in an opposite direction to the forward motion of boat and flock, stabilizing the elements of the composition within the boundaries of the picture plane. The sunbather is both form and content, uniting the two major shapes, and symbolically joining the human community to the world of nature. We must stand in awe that a six-year-old created this astonishing compositional device.

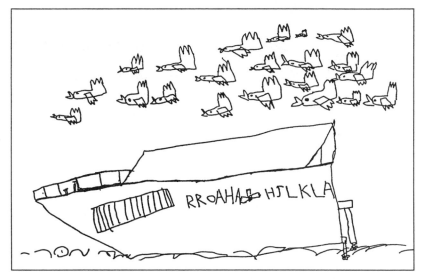

Figure 5.5 From *Boat Holiday*, boat and gulls isolated to highlight the similarity in shapes.

Figure 5.6 From *Boat Holiday*, shows the pivotal importance of the sunbather.

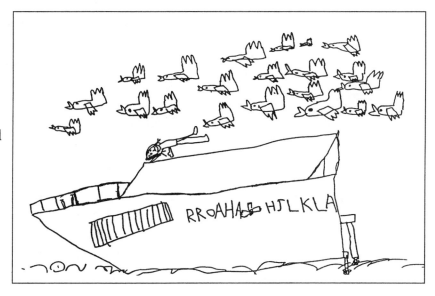

An analysis of Attacking the Snake

In *Attacking the Snake* (figure 5.7), three airplanes fly in combat against a wingless serpent, which is spiraling through the air. There is no sign of distress on the snake's detached features. Each fighter plane has fired a tracer bullet. Each bullet attaches itself to the snake, making lines and shapes that contribute to formal organization and narrative drama. Form and content are one. Two spotted animals are lined up along the base of the drawing. The only airplane with wings appears to be grounded. It could be interpreted as a mythical encounter: snake, possible archetype of male sexuality; attack planes manned by expressionless robots; spotted animals of ambiguous significance.

David, like many boys his age, made hundreds of war drawings. Most of them show empathic involvement and radiate aesthetic energy, although *Battle Scene* (figure 5.8) is weak in these qualities compared to *Attacking the Snake*. When David did war drawings, he scribbled tracer bullets while imitating their sound. He was empathically involved, but the drawings were weak in the formal elements that generate aesthetic energy. Empathy in itself, apparently, does not make a work of art.

Some twenty years later, David commented on drawings he made as a child. This is what he wrote about *Attacking the Snake*: "Three airplanes, two cows in a field, and a snake. The dividing up of space is gorgeous. The need for strong composition, for order, is due to my overemotionalism.

Figure 5.7 *Attacking the Snake* by David, age 6.

Draw Me a Story

Could I have been scared by a snake in real life, on television, or in a book, and these airplanes are attacking it? Protecting the cows who are friendly creatures?"

In contrast to the violence of *Battle Scene*, there is an air of calm about *Attacking the Snake* which suggests a symbolic drama, not a real one. The attack is precisely choreographed and the snake makes no effort to escape or retaliate. It dominates the composition with its imposing 'S' curve, head soaring into space above the action. Here is a test of its formal unity: imagine, for example, a fourth airplane placed at the level of the snake's head. The formal structure would be weakened and little would be added to content. As it

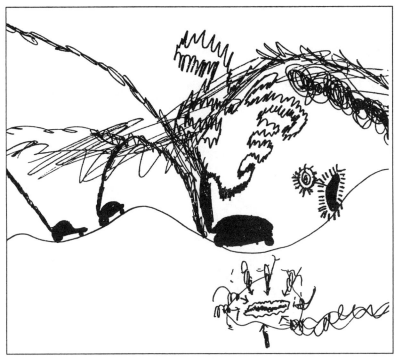

Figure 5.8 *Battle Scene* by David, age 6.

is, the overall effect is open and spacious, but the forms are linked in a tight network of relationships. The snake supports the rest of the drawing like the pole of a tent. The cows are integrated into the composition through alignment; cows and the grounded airplane form the base of a triangle with the snake's head at the apex. Three formal devices lead us to it: the snake's body, the three flying machines, and the dots which gradually diminish in number until the solitary eye of the snake is reached.

Attacking the Snake could be viewed as little more than a six-year-old's typical battle scene, but art resonates at a deeper level where images become archetypal. This is a drama involving earthbound and sky-soaring players who are aggressive, but not seriously intent on destruction. The content may be a battle of good against evil, or it may indicate a struggle to integrate personality.

An analysis of Lucy Was Tired Now

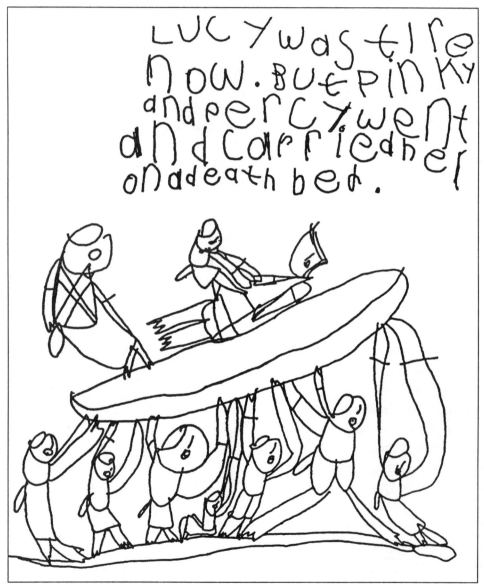

Figure 5.9 *Lucy Was Tired Now...* by Joanne, age 6. Her text on the drawing reads: 'Lucy was tired now. But Pinky and Percy went and carried her on a death bed.'

Joanne had only ten percent of normal vision, yet she drew constantly. *Lucy Was Tired Now...* is the twenty-third drawing in a series of twenty-four drawings describing the adventures of Lucy and her friends. (More drawings in the series are found in Chapter Ten.) Drawings and text are her own inventions; she received no help from adults or other children. The story is happy and playful except for this one sombre episode. If we accept that all art is more or less autobiographical, we can speculate that Lucy is really Joanne, and the story recounts her struggle to lead a normal life. While all the drawings are imaginative and charged with aesthetic energy, this one, I believe, reaches the status of art.

The character of Lucy is a gregarious babysitter who loves to visit the homes of friends. Earlier in the series, she is shown carrying children, presumably the burden that leaves her tired. After happy adventures she is carried, exhausted, to her 'deathbed.' We must wonder where a six-year-old would pick up the concept 'deathbed' and use it to create an image of such heroic exhaustion. In this

episode, the story and drawing become unconsciously mythic and archetypal.

In figure 5.10, part of the drawing has been isolated to illustrate the formal device of tension and equilibrium. Pinky and Percy have lifted Lucy to the deathbed. She is tired but not yet at rest; one of her friends braces a foot against her chest and gradually lowers her. Joanne appears to understand the physics of push and pull. Lucy's feet, shoulders, and head are held stiffly in the air, suggesting a reluctance to give up the struggle. Aesthetic energy is generated when forms are held in tension in a state of equilibrium. The attempt to support Lucy from below verges on disaster. She and the bed create an unstable diagonal, sliding to the lower left. The larger of her two companions is thrown off balance and leans crazily away but at the same time, breaks the downward momentum with an upward counter-thrust. A second stabilizing force is the combined support of Lucy's friends: fourteen arms and fourteen legs link the stone slab to the ground. In Joanne's drawing, the key figure is the smallest one in the middle, holding on desperately, comically squashed, the fulcrum of a teeter totter. Following her extended arms, we are led to the central drama, Pinky straining to let Lucy down gently. Forms are thus aligned to complete a motif of crossed diagonals, again, the 'hidden order of art.'

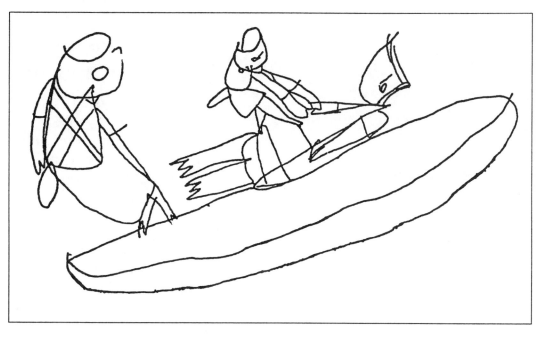

Figure 5.10 Detail of *Lucy Was Tired Now...*

Aesthetic Energy, Aesthetic Experience, and Their Healing Power

There was a time when meadow, grove, and stream,
The earth and every common sight,
To me did seem
Apparelled in celestial light...
— *William Wordsworth*

Wordsworth and our adult memories suggest that aesthetic experience is common in early childhood and diminishes with the arrival of self-consciousness. I view the aesthetic experience of nature as a precursor to aesthetic energy in art. This fusion of self and other cannot be forced but it may be subtly orchestrated. We can set the stage by taking children for walks in the woods; by suggesting that we sit quietly and listen to birds and insects; that we watch the wind in the trees or listen to the lapping of waves. I consider my prairie childhood to have had a positive effect on my own art. I recall, at age three, discovering that the sunset was enhanced if I turned my back on it, and bent to survey it through my legs. I had discovered the detachment that intensifies aesthetic experience. Children are more likely to imbue their drawings with energy and occasionally reach the status of art if they experience the aesthetics of nature.

Teaching Styles and Practical Suggestions

*T*his chapter is focused on organizing drawing programs for various age groups. It describes a remedial approach for post-naives which I call the 'theme and variation strategy.' Our overall purpose is to recognize and nurture drawing as a spontaneous language, and extend it beyond the crisis of self-consciousness. It is reassuring that drawing, so valuable to the child's mental development, is not particulary difficult to motivate or teach.

A mother of two young boys wrote to the Drawing Network Newsletter:

As the parent of two boys, Michael, age nine, and Steven, age seven, the intrinsic value of drawing is becoming increasingly apparent to me. From the time my children were old enough to hold a pencil without hurting themselves (approximately one year of age), they have had free access to paper and pencils. There was a cupboard in our kitchen full of inexpensive newsprint and other drawing implements. Along with these materials, they were given an atmosphere free of criticism and abundant appreciation. I can honestly say that rarely a day has gone by that they haven't done some drawing, and frequently they spend more than half an hour a day expressing themselves on paper. I feel that there is a

Post-Naive: a new term to identify older children, young people, and adults who are self-conscious about their drawing.

Figure 6.1 *A Girl That Could Change Into a Dolphin* by Michael, age 9.

Figure 6.2 *A Video Game* One of a series of forty-nine on the same theme, by Steven, age 7.

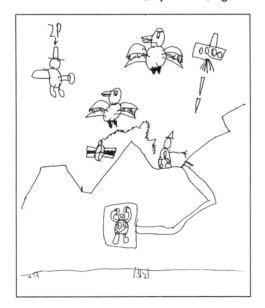

direct correlation between their prolific drawing and their excellent performance at school. Both boys have been in their school's Challenge Program for bright children and continue to amaze us with their academic achievements. But even more important than the good grades is their love of learning. Their eagerness to absorb knowledge of any kind seems directly related to the way that they process information in their drawings.

The mother of Steven and Michael made sure that materials were at hand, the atmosphere was positive, and so the boys found pleasure in daily drawing. There are times, however, when children need motivation, and this is a challenge to the adult imagination.

Routines for Children and Post-Naives

Six years ago I started the Drawing Network in the hope of raising awareness of drawing as a language phenomenon among parents, teachers, and academics. Newsletters and pamphlets were published. One of the first was called 'Thirty Days of Drawing,' which provided guidelines for a trial period of daily drawing at home, or in school. This chapter is based on the material in that pamphlet.

Basic requirements for children at home, in preschool, kindergarten, and primary

When children are first able to hold a pen or pencil, drawing should be a daily experience at home and later, at school. A period of fifteen or twenty minutes should be set aside for supervised drawing, if possible in the high energy part of the day. A regular place to draw with a suitable table, storage space for materials and finished drawings, and a bulletin board for current work is ideal, but is not essential.

It is not enough to say, "Drawing time!" and then leave the child alone. At home, parents need to be available to discuss topics, and participate in the creative process. Admiring the finished product is one way to create a positive ambience. When a daily routine has been established, parents can judge when their presence is needed. I am convinced that the timely motivation of parents and teachers is the most important essential of a successful drawing program.

A ballpoint pen is the best drawing tool, even for young children, although water soluble fine point felt pens are also good. A good quality ballpoint gives a steady flow of ink and one with a fine point encourages the inclusion of details. Ballpoint also cannot be erased—a good characteristic—as children should not become concerned with correctness, a preoccupation which can interrupt the drawing's progress. *Mother and Child* (figure 6.3) was sent to me by a primary teacher who wrote: "We keep a pot of ballpoint pens for this purpose only [drawing]. I'm amazed at the detail they achieved in their Christmas drawings."

Any paper will do, but computer paper is ideal. Some materials need supervision. Care should be taken to avoid those that are toxic. If paint, oil pastels, and other more exotic media are used they should, of course, be supervised.

Visualization, guided imagery

Before drawing begins the theme or subject should be discussed. Visualization is 'seeing' images on the inner screen of the imagination. In guided imagery, we ask children to shut their eyes and imagine episodes from a story that is being told, or a picture being planned. ("Can you see a picture, even when your eyes are shut?") With older children this becomes a remedial technique, for the younger child, it is usually enough to tell the story, or motivate in some other way. Still, visualization is a unique and valuable gift

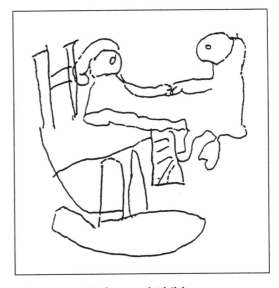

Figure 6.3 *Mother and Child* anon. Grade one children made drawings for Christmas based on a mother and child sculpture by Henry Moore. They used ball point pens.

of considerable significance to older children and young people and a beginning should be made in the early years.

Empathic identification

A child's drawing of 'My Mom' is usually rich in empathic identification. Drawing with empathy means that the 'self' is lost in subject matter and process. The drawing will seem right to the child even though the head-body circle, extended limbs and happy face may appear crude to adults. If we accept the image for what it is, a symbolic abstraction of the child's reality, a strong foundation for future growth is established.

Motivating children to draw

As soon as children see that marks have representational value, motivational strategies come into play. The following are examples.

- Telling or reading stories that evoke strong images and interesting narratives; discussing favourite books, songs, television programs.
- Showing how mechanical things work and then drawing them, e.g. a toy, a kitchen appliance, a means of transportation, a space station, a mine shaft, an assembly line.
- Discussing and drawing themes that relate to family life, school, community, personal and social problems; exploring emotional responses, e.g. the story behind a temper tantrum, responding to a family illness, the fear of going to bed, a reaction to a new baby brother or sister, new neighbours who belong to a visible minority.
- Setting up and discussing still-life subjects, inviting visitors to pose for a drawing, encouraging children to draw their pets or to bring them to school, or drawing

ideas, themes, and specimens that relate to science and social studies; learning to observe carefully through drawing by examining and drawing flowers, animals, the human body.

- Recalling and drawing happy memories such as a holiday trip, visiting relatives, a trip to the zoo and so on.
- Organizing visits to community institutions, e.g. fire halls, hospitals, museums and so on. Drawings can be made on location or back home, or in the classroom.

Coloring books and adult models

Showing children examples of 'correct' or naturalistic work by adult artists or talented children is far from helpful because it provides a model difficult to emulate and takes the emphasis away from individual expression. Nor is drawing-as-language served when children color-in photocopied outlines, are subjected to the technique known as 'directed drawing,' or given coloring books. These activities contribute nothing to intellectual development, the search for knowledge, or emotional well-being. Worst of all, they weaken the child's natural gift for drawing.

A correspondent to the Drawing Network remembers exactly when she lost interest in drawing. As a child, one of her favorite subjects were rabbits. Someone had given her a coloring book, and one of the pages was devoted to rabbits. She suddenly realized that hers were not nearly as realistic. From then on she found no pleasure in drawing.

Encouraging Children's Drawing in Late Primary, Intermediate, and Junior Secondary

The way one intermediate teacher (Marne St. Claire of South Park Family School in Victoria, BC) organizes daily drawing with her class shows how it might be used successfully with young post-naives.

Yikes! I've just coached the volleyball team through my lunch break and it's 1:00 p.m. and I haven't prepared my afternoon social studies lesson with my grade five/six class. As a classroom teacher, I am often caught with the panicky feeling of never having enough time to prepare materials and lessons for my boisterous students.

When I need my day to slow down, I reach for the package of photocopy paper I keep in my room and announce, 'Daily Draw time.' My students eagerly ask, 'Our choice, or yours?' While they grab a pen from their tool boxes, I hand out a paper to each child and announce, 'My choice!', and reach into my mind to take out an idea to inspire today's drawing.

I say to them: 'I have just been coaching volleyball and noticed that the team is getting much better at using their legs for jumping high to block and spike. Could you spend twenty minutes quietly drawing excellent blockers and spikers? Put in yourself as one of the team if you want. Try making your players look very involved in the game. Please remember not to talk during drawing time.'

Whew! I sink into my chair and quietly eat my sandwich while I enjoy the sound of pens on paper. Daily Draw is a teacher's best friend. Ten minutes later I get out the socials manual and glance through the lesson plan. After their twenty minutes of drawing, I ask my

students to turn their drawings over, write their name, date, and title on the back and file it into the drawing folder in their desk. Showing their work or displaying it is optional; privacy is respected.

Students prefer to choose what they want to draw and they would rarely choose something as complex as the human form playing volleyball! That's why I let them draw what they wish every third time or so. Because I'm training them to sustain their drawing, I encourage them to take out one they've already started and continue to work on it, adding the new date to the back. I discourage cartoon drawing because I am convinced that if I am really developing observation skills, memory, and empathy, I'd like them to 'get into' the object they're drawing more than cartooning allows. If cartooning is a love of theirs, I encourage them to do as much as possible — at home in their own time.

What I love about Daily Draw is that I don't have to be an expert drawer. I challenge my students to 'tell me more', but I never have to show them how to draw. When one says to me, 'I can't draw,' I take them to mean, 'I want this to look more realistic.' So we go to whatever the subject is, usually the human body, and look at the knee joint or the thickness of the arm. Usually the student is willing to take that as support for trying to get closer to his ideal. I also remind them that Leonardo da Vinci drew all day and all night for years and years, and that they are young and only draw twenty minutes three or four times a week. What do they expect? Now that I've been doing this for years, my students settle into their drawings seriously and with enthusiasm, giving me time to catch my breath while they spend time in learning how to describe their world.

Suggestions for Teaching Drawing to Post-Naives

We must, of course, recognize time restrictions because of formal curricula. Each structured course of studies requires that a great deal of content be covered in all subjects. To add drawing to the mix, it is necessary to choose materials and techniques appropriate to a limited time frame. Contour line drawing best serves this purpose. Not only is it the least time-consuming, it is superior as a tool for articulation, expression, and communication, and best satisfies the definition of language. Color, tone, and texture are best dealt with in art classes; line drawing is most useful in science, social studies and language arts.

There is likely to be a need for remediation in the post-naive group, that is, when children leave primary for the intermediate and secondary grades. Visualization and guided imagery has been mentioned and the next chapter is devoted to the 'drawing game,' an approach I have successfully used with intermediate, secondary, and university students.

I have found that scheduling alternating days of self-motivated or free drawing —"your day"— with days when the teacher chooses the theme and strategy —"my day"— works well. In free drawing periods, children are encouraged to draw their own themes in their own way with two exception, no pornography or gratuitous violence.

Opting out

When the teacher motivates the drawing, children should not be permitted to 'opt out' any more than they would from a math lesson. The reply to "Can I draw something else?" should be a firm, "No, you'll get a chance tomorrow." There are two reasons: first, in order to grow, children must

face new challenges, in drawing as in other disciplines. Frequently, the reluctant one is the 'talented' drawer who has mastered a secure but stifling formula. They, too, need to learn new techniques and try to draw new subjects. Second, teachers use drawing to develop concepts, skills, and strategies children wouldn't think of on their own, and to guide them into specific areas of subject matter.

Integrating drawing into the general curriculum

In late intermediate, the curriculum becomes more specialized and there is less time for art, even less for drawing if it shares time with other visual arts media. The Daily Draw approach is excellent, especially for dealing with themes of personal development. On the other hand, there are many places in the curriculum where drawing, either alone, or in conjunction with writing, can be beneficial to learning, particularly in language arts, science, social studies, and art.

In core subjects, learning is the criterion. Art practices that do not contribute to learning should be avoided. While supervising student teachers, I often saw children coloring-in projects in social studies, language arts, and science. Very little was being learned. Coloring-in may be popular with children, but it is time consuming and without educational value. Time spent on coloring-in and making fancy lettering for booklet covers would better be devoted to doing original research, and recording what is learned in writing and line drawing. We realize that children love to enhance their drawings with color, tone, and texture, 'finishing' them with these exacting and time-consuming techniques. We can stress the importance of line and still allow children to add color, tone, and texture to their best work in free time at school, or in leisure-time at home.

Scheduling

When formal timetables and subject platooning are used, drawing may be scheduled in these optional ways.

- in a regular time-slot in the high energy part of the day for ten or fifteen minutes, much as free reading is done in some schools
- integrated with other subjects and practised throughout the day
- providing for personal or free drawing as part of keeping a journal
- a combination of regularly scheduled 'daily draw' sessions and drawing integrated throughout the curriculum

Coping With the "I can't draw" Syndrome

The virtual disappearance of drawing in the late intermediate years is a serious blow to a potential for maximum development and learning, and very little has been done about it. There are a number of causes. One cause is the weak position of drawing in the home/school curriculum. By the time the intermediate grades are reached, children have had seven or eight years of instruction in the codes of literacy. In contrast, most have had little background in drawing. Another cause is that drawing exposes the child to peer opinions and pressure. Students are not often able to read each other's writing, but drawings are visible and open to comment, particularly if they are routinely exhibited.

The attitude of society about what constitutes 'good' drawing is also a factor. Older children become self-conscious and lose faith in their ability to draw. "I can't draw" becomes a familiar reaction, and we are prone to

accept their reluctance as inevitable. It is, of course, a problem, but imagine how standards of literacy would fall if we accepted such an excuse in teaching writing. In the next chapter, I will describe the 'drawing game' a remedial strategy which has worked well for my students.

Theme and variation: A remedial strategy

At ten, David was experiencing the typical image block of the 'I can't draw' syndrome. He had been a prolific drawer in preschool and in his primary years, but suddenly felt inadequate and disinterested. He was in a class where daily drawing was as regularly a part of the day as reading and math. His teacher noted that he lacked enthusiasm, but wisely kept him involved. One day she found him working on the drawing *South Sea Fantasy, Version 1* (figure 6.4). He was completely absorbed. This was a result of patient teaching and, for David, a return to drawing at an age when many abandon it. She encouraged him to make more drawings on the same theme. When David's teacher told me this story, it suggested a remedial strategy for post-naives, one which would build on success. It works as follows.

- The teacher identifies a "breakthrough" drawing and praises it. The child is asked which parts are successful and why. After the interview, a new drawing is done, a variation of the first.
- Possible variations are discussed: "What would the drawing be like if the time were changed from day to night or the season from summer to winter?" or "... Wouldn't it be interesting to make a second drawing, including everything in the first one but from a different point of view?" Or the teacher might simply say, "...that's a very exciting drawing, and I like the way you did it. Could you do a second one on the same theme tomorrow in daily drawing?"

Figure 6.4 *South Sea Fantasy, version 1* by David, age 10.

Figure 6.5 *South Sea Fantasy, version 2.*

'Found images' using the double-L viewfinder

Teachers and students may find a double-L viewfinder useful in planning second or third versions of existing drawings, or in finding drawing subjects within photographic material. A double-L viewfinder is made by cutting two 'L' shapes from cardboard which can be placed over a drawing or photograph and adjusted as a sliding frame to isolate interesting segments. For children who are looking for drawing themes, the viewfinder offers endless possibilities.

Motivating drawing with expressive themes

Figure 6.6 A 'found image' using a double-L viewfinder from *South Sea Fantasy, version 1.*

I have paintings in my collection by fourteen-year-olds who responded to a story about being lost in the woods. After describing the situation and discussing it with my class, I asked them to make portraits of themselves in this dire situation. The finished paintings look like works by German Expressionists such as Kirchner or Nolde. The young artists understood that to express fear, exaggeration and abstraction were needed. Even when the main thrust is in the direction of realism, teachers should occasionally motivate drawings that express fear, anger, love, and so on. Some children remain rooted in abstract symbolism and use expressive exaggeration naturally. As long as this satisfies them, no attempt should be made to bring about change.

The Drawing Game

My first teaching assignment at UBC was an art methods course for aspiring elementary teachers. It included the psychology of child art, the stages of children's image development, and the introduction of as many studio techniques as time allowed. Before beginning the hands-on section, I said, "Don't be concerned about the images you make; our goal is to learn the techniques of art so you can teach them to children." But, as we worked on the techniques, stereotyped images were the rule, not the exception. Learning how to make paintings, block prints, collages, dioramas, and clay sculptures was interesting, but students found little satisfaction in using them to make Walt Disney cartoons, 'happy faces', lone pine trees by a lake, and so on. I soon realized that if they didn't learn to do art motivated by personal experience themselves, they were unlikely to teach it to children. This was difficult for these non-art majors who had very little background in art and, like most young people, suffered from self-consciousness when asked to create it out of their own personal experience. The challenge was to find ways to overcome this handicap. I wanted to help them become teachers of authentic art by showing how they could practise it themselves. The drawing game evolved from this.

By studying the art of younger children, we established what authenticity meant, noting how children translate personal experiences into images, how they use materials spontaneously, and how they draw to tell stories in the most direct way. We also talked about the loss of confidence older children feel. Through studying examples of 20th century figurative art, they came to appreciate the power of exaggeration and expressive abstraction. They could see that these qualities intensified feeling and enriched meaning, even though naturalism was sacrificed. This helped them become sensitive to the aesthetic qualities in child art, and it increased their tolerance for the distortion and exaggeration which would appear in their work when I introduced the drawing game as a remedial strategy. The game would impose arbitrary rules on their performance, and they would be asked to respond to a theme as children might, directly and spontaneously. For the most part students enjoyed it; if nothing else, they gained insight into the challenges intermediate children face when they try to make authentic art.

An Overview of The Drawing Game

Older (post-naive) children no longer feel comfortable drawing and, faced with the codes of literacy, rarely experience empathy or authenticity when they use language. The exception is the easy flow of conversation heard at home and on the playground. The drawing game is an approach aimed at restoring empathy to language for the post-naive group. (In modified form it can be used in late primary or whenever self-consciousness causes individuals to say "I can't draw." Briefly, it is simply applying game theory to drawing. The teacher assumes the role of coach. The game is explained. Drawers are reminded of their previous

Figure 7.1 *Children Playing*
A first game drawing by a
school principal on study leave.

experiences of learning new games when following the
coach's instructions was a rule. Moreover, children will see
that mastery of any game is a result of concentration and
practice.

The primary rule is that the pen must be kept moving
in a steady flowing line that corresponds to the observed,
remembered, or imagined contours of forms. This is
referred to as the "continuous line rule." (Young children
perform this way when they draw and, at a more sophisti-
cated level, so do mature artists.)

Empathy is restored to drawing through an invoked tactile sense. That is, the drawer imaginatively, 'touches' the form by drawing it. This suggests a somewhat deliberate pace which allows the tactile sense to come into play. With practice over a number of sessions, the drawer begins to make contact with the intuitive preconscious where the integration of perception, thought, and feeling takes place. Confidence is gradually restored as the pen seems to take responsibility for the drawing; the drawer goes on 'automatic pilot.' The strange (or unrealistic) look of game drawings is soon taken for granted, and a review of a series will reveal a gradual increase in realism. Moreover, the experience feels good even when the results seem somewhat crude.

Curiously, game drawings exhibit the qualities of good design we found in *Boat Holiday, Attacking the Snake*, and *Lucy Was Tired Now* analysed in Chapter Five. Certainly aesthetic energy was more in evidence in the game drawings of my elementary student teachers than anything else they had produced, although they were not always able to appreciate it. The most exciting results came when I introduced game drawing to art education majors in my printmaking program. Here we had time to use the strategy to produce authentic images on a more sophisticated level and to transform them into prints.

Game drawing from imagination, memory, and observation

Game drawing can be used as a remedial strategy in three modes which, as we will see in Chapter Eight, should be given equal emphasis: drawing from imagination, drawing from memory, and drawing from observation. If drawing from imagination is featured, the coach chooses a subject, reads a story, describes an event, uses visualization and guided imagery. If drawing from memory is the focus, an

object is studied carefully and removed prior to drawing; or a past event is suggested as a theme, discussed, and visualized. If drawings are to be done from observation, either a still-life or a posed figure is arranged in front of the class, or a location or event is organized.

The continuous line and classical line rules

The term 'classical line' has been defined earlier (page 66) but it bears reviewing here. It can be described as smooth, unvarying, always moving forward, taut as a wire, never jiggling back and forth. It is the line of early Greek ceramic decorators, or classical artists such as Ingres and Picasso in his classical period. It is important to the drawing game because classical line is the way most children draw spontaneously. The drawings in this book provide good examples.

At first, the entire drawing is done with one continuous classical line, but modifications are introduced as soon as confidence begins to build. Students are allowed to lift the pencil or ballpoint pen to relocate when they reach a natural stopping point, that is, when the line can no longer continue without creating an extraneous path, an unwanted line that describes nothing and is used only to get from one point to another. The continuous line rule may seem artificial and awkward at first, but this feeling soon disappears and the drawing takes on a sense of inevitability. The process has been described as being on 'automatic pilot' or 'the drawing seems to be drawing itself.' This feeling has its origins in the preconscious where the performance resides. Breaking the continuous line rule (a strong impulse at first) brings the performance to a sudden halt, and the role of self-conscious non-drawer is resumed.

After a few sessions of strict adherence to the continuous line rule ("Lift only to relocate the pen!"), the rule can be relaxed somewhat. ("This time, if you get the urge, you can lift the pen from the paper but try to keep it moving

just above the surface, feeling the form but not quite touching it. Then, when your intuition tells you, drop it to the paper and resume mark-making.")

Contour drawing: definition and introductory exercises

In contour drawing, the line made by the pencil follows and replicates outlines and edges, whether the subject is imagined, remembered, or perceived. (Outlines are not necessarily edges, although they may be: think of an egg which has an outline from every possible point of view, but no edges.) Depending on the age and background of the students, contour line drawing can be taught by selecting activities from the following:

- A complex object such as a shoe or a flower is examined for edges by each student. It is carefully observed and later becomes the subject of a first drawing. Attention is focused on *outlines* (the overall silhouette) and *inlines* (the interior structure of complex forms).
- With the object clearly visible, the drawer makes a tracing in the air, or on the surface of the desk, with the forefinger, replicating the contour edges as carefully as possible.
- The exercise is repeated from memory with eyes shut.
- Drawing from imagination is motivated by reading a story, or describing an incident. Then, drawers shut their eyes and trace the edges of the imagined forms.
- The teacher may refer to the preconscious, that part of the mind which intuitively controls the drawing. We want to program it so that the forms will be remembered, or imagined more clearly. Students are reminded that the drawing will show the influence of careful observation, visualization or guided imagery, but they shouldn't expect a realistic image to appear on the

paper. If naturalism is the goal, it will come only over a long period of practice.

- Photographic images are projected on a screen which children draw in the semi-darkness as though the real object is observed. The image is left on the screen for the entire drawing, or it is studied and then drawn from memory with the lights on.

Additional lines are permitted as corrections, providing the original lines are not traced over. These additional lines create an aura of energy around forms and leave interesting traces of the struggle to achieve correctness. We see this in many old-master drawings which can be used to illustrate these points. Retracing or going over the line ("spinning your tires") allows self-consciousness to re-emerge and, in the process, lines become coarse and unpleasant.

The empathy-touch rule

When young children draw, they relive their experiences so intensely with empathic identification, that touching and seeing seem to be combined. It is this involvement with two senses that gives drawings such a strong feeling of authenticity. Watch children draw. They seem to be carving the lines onto the paper. 'Touching' in this context is, of course, imaginary and metaphorical, a product of a contact with deeper levels of consciousness. We notice that children briefly 'lose themselves' in their drawing, much as mature artists do. The advice of oriental artists can be paraphrased as follows: "To draw the bamboo, become the bamboo." We can expand on this to increase our understanding of the role of empathy in authentic art:

Figure 7.2 *How a Child Feels When a New Baby Comes* by an elementary student teacher.

To draw the bamboo, imagine touching it with the pencil, as eye and hand follow the contours precisely; the bamboo drawing will appear magically on the paper as a convincing symbol of the real thing, even though the forms may be abstracted and distorted.

The tempo rule

The correct tempo for the drawing game is a somewhat deliberate pace, required to allow the tactile sense to come into play. It can be described as 'feeling' the form, as though the drawing tool were being dragged across a resisting surface. It is important not to draw too quickly or too slowly. Metaphors are useful here: the tempo should not be like driving on the freeway, or like entering the driveway, but as though driving on a city street free of traffic.

The value of detail—and no rough approximations

The objective in the drawing game is to replicate forms as accurately as possible, while maintaining the continuous line rule. Drawing rough approximations of forms is discouraged, that is, sketching quick impressions rather than following precise contours.

Complex subjects have complex contours and make the most interesting drawings. But when students are instructed to keep the line moving, drawers may gloss over the details which articulate information, especially in science and social studies. In game drawing, continuous movement and attention to detail are both essential.

Models for Teaching Game Drawing to Different Age Groups

The following motivational strategies presented as monologues are for introducing the drawing game to different age groups. They are meant as suggestions, adaptable for individual use relative to the age and background of students. I have found that drawing people in costumes and masks offers more freedom to students as they are especially inhibited about drawing the human form. Hallowe'en or a fancy dress party are possible themes for masks and costumes. You will notice that the following monologues are examples of quided imagery.

Game drawing with minimum rules for younger post-naives

Have the children draw in classical line using a ballpoint pen. Tell a story or describe a situation. Using guided imagery, help the students visualize a particular scene. Say little about technique or rules.

FIRST MONOLOGUE

As you know, Hallowe'en is coming soon and, as you have a cold, you are not allowed to go out 'trick-or-treating.' You must stay at home and pass out the treats. When you answer the door, what do you see? Imagine the kids in costume. This is what I want you to draw. Don't put in the door until you're nearly finished. That will give you more freedom to arrange the characters.

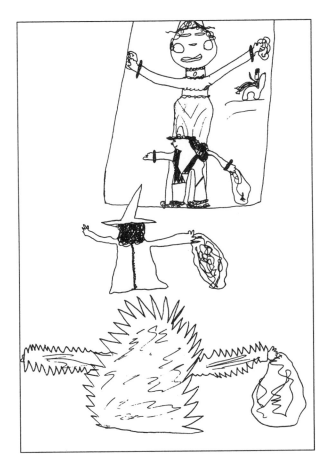

Figure 7.3 *Hallowe'en: Answering the Door* A first game drawing by an elementary student teacher.

Game drawing with modified rules

Before and after comparisons are often helpful. In a single drawing session, I used the first and second monologues (or something like them) to illustrate the value of the drawing game. The first drawing was simply a response to a story and was done without 'rules' (first monologue). As my adult students were extremely self-conscious about drawing, they would make many false starts and generally perform poorly. I would then move immediately to the second monologue (below) with its introduction to game drawing rules. Students always recognized an improvement in the second drawing. Moreover, they felt good about the technique of 'letting the drawing draw itself'.

The more structured second monologue can be used as an introduction to game drawing for post-naives of any age.

SECOND MONOLOGUE

You are finding drawing more and more challenging. Why do you think this is? Do you think that you are getting older, more self-critical, and want your drawings to look more real? Today I am going to introduce a game. It is not intended to make you draw more realistically in the immediate future; that will come with time and practice. It will help you draw more spontaneously and lose your fear of drawing.

I'm going to describe an imaginary event. I want you to shut your eyes and see on the 'inner screen' of your imagination a picture I describe. You are to use only line and the drawing is to be made without stopping, one continuous line from start to finish. You can lift your pen when you want to relocate on the paper, but keep the line moving steadily.

A structured drawing game for older post-naives

Older post-naives suffering severely from the 'I can't draw' syndrome may require a more structured approach, involving all the rules outlined above.

THIRD MONOLOGUE

Today is 'my day' for choosing a theme and method. I am going to introduce a new drawing technique which will help you develop your own style and ideas. We have talked about authentic drawing. We have agreed that this is a good goal, but you wonder how to begin.

We have talked about drawing as a game, one you could learn by practising conscientiously and paying close attention to your coach. All games have rules and so does this one. We'll use ballpoint pens so you won't be tempted to use the eraser. I will expect you to use only classical line. Remember that classical line moves forward at a steady pace with no going back and forth, no jiggling. Another rule is, once you begin drawing, you must continue without stopping and without lifting your pen from the paper. You may cross over lines that are already there, but do not go back over the same line twice. It doesn't matter if the forms don't satisfy your standards for realism. That will come with practice. There is one exception to the 'no lifting' rule; if you have reached the end of a contour and you don't know where to go next, stop for a moment and lift the pen to a new location, but try to keep the line moving above the paper. You can think of this rule as a jet plane flying: if it stops, it falls to the ground.

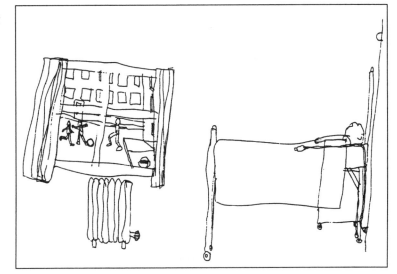

Figure 7.4 *Memory of Going To the Hospital* A game drawing by an art major in a teacher training program.

Figure 7.5 *Two Boys Flying Kites In a Cow Pasture* A game drawing by an art major in a teacher training program.

Although the drawing game is a remedial strategy, it may be used in a modified form after the need for remediation has diminished. I have found that older students, especially those with a background in art, internalize the strategy quickly and evolve their own style of drawing.

Game drawing for teaching perspective

Game drawing can be used to introduce depth and perspective, important concerns for young people. The Hollowe'en theme is used again.

FOURTH MONOLOGUE

Please shut your eyes and remember some of the figures you had in previous drawings. Change them if you wish, bring in new ones, or change their positions. Shift them around as though you were directing a play. Open the door and get a picture of them. Look straight ahead, not up or down. Notice that the figures farther back are partly obscured by those closer to you. This is called 'overlapping planes,' a device for getting perspective, or making one thing look farther away than another. Don't worry if some of your lines show through, giving the figures a transparent look. We can avoid this by drawing the nearest things first.

Next, imagine at least one figure quite far back. Keep the figure entirely visible, no overlapping planes this time. Notice how small it is compared to the ones that are nearer. This is a way to show depth in your drawing. We know that things appear smaller as they are farther from us.

The influence of game drawing in prints by art majors

At UBC, I taught printmaking in a studio program for preparing specialist art teachers. Game drawing became an integral part of these courses for helping students develop what I called 'authentic personal imagery.'

In senior printmaking courses, the drawing game was internalized so that remediation was no longer needed. I close this chapter with three exemplary prints to show how game drawing, a strict discipline with rules, can lead to personal freedom of expression. These students had evolved a mature and consistent way of making authentic art. *Shining Star* (figure 7.6) shows the influence of the drawing game approach, which had the effect of moving some students in the direction of 'naive' primitivism.

Susanne Gartlan made many drawings using a modified game approach, and out of these came a number of prints: woodcuts, linocuts, etchings, and drypoints. A drypoint is made by scratching lines into a metal plate with a drypoint needle. After filling the lines with etching ink, it is printed on damp paper using an etching press. The unusual composition of *Reaching Child* (figure 7.7) was probably the result of conscious planning and preconscious or empathic drawing, possibly the synthesis of a number of game drawings.

Figure 7.6 *Shining Star* A woodcut on the Nativity theme by Mike Doherty, a senior art education student.

Figure 7.7 *Reaching Child* by Susanne Gartlan, a senior art education student.

Intense involvement in game drawing preceded a series of lino block prints by a senior art education student. Ray Lorenz was moved to make prints on spiritual themes. *Music of the Spheres #3* (figure 7.8) was first carved in lino, then printed on an etching press.

Figure 7.8 *Music of the Spheres* #3 by Ray Lorenz, a senior art education student.

Planning a Balanced Drawing Program

When children draw, a complex web of mental activities is involved: perception, cognition, memory, imagination, empathy, and a wide range of feelings and emotions. These are, of course, interdependent and any drawing involves all of them to some degree. However, this does not prevent us from giving a special focus to one or another of these mental activities from time to time. In separate lessons, we can concentrate on perception, by drawing from observation or with the model near-by; focus on cognition, by using drawing to solve problems and acquire knowledge; focus on memory, by drawing important events from past or recent experience; focus on imagination, by drawing themes of fantasy; or call upon feelings/emotions, by drawing themes that evoke emotional responses.

Imagination, Memory, Observation: Three Ways to Motivate

To provide a balanced drawing program, we can explore three ways of motivating children. Consider briefly how each of the following three methods relate to one another:

Drawing from imagination without recourse to a model, real or remembered, depends on combining forms that have been previously perceived, stored, and remembered.

Drawing from memory is a symbolic reconstruction of fragments stored in the preconscious. These have their origin in earlier perceptions and depend on imaginative selection.

Drawing from observation may seem to be an act of pure perception but memory and imagination are also involved: memories of past drawings stored in the preconscious guide the hand even as the drawer refers to the visible model. Selection (what to include, what to leave out) is a necessary part of the process and involves the imagination.

Drawing from Imagination

Make-believe is important to intellectual development and mental health. It is an integral part of a healthy childhood. I remember pretending I was flying over a jungle, in reality a patch of weeds, grasses, and flowers. Insects became wild animals viewed from a thousand feet, bare ground became a clearing in the forest. Pieces of junk or bits of lumber were jungle villages or an ancient ruin; lichen-covered stones were towering mountains. Psychologists tell us that such play is vital to the growth of intelligence and to mental health.

This is what Geoffrey told his mother about his drawing, The Blue Jay-anteater (figure 8.1).

This is a war. The Blue Jay-anteater has one horn on his front and some on his back. The dragon is breathing fire in the Blue Jay-anteater. You will see colors and then you will know where the fire is coming from. If it's orange, then find the ones that are orange and then you'll know that's the one. They are both breathing bullets out.

Geoffrey may have been 'romancing the drawing' when he told his mother the Blue Jay-anteater story. Children often make up explanations of drawings after they are finished. 'Romancing' testifies to drawing's power to stimulate imagination and discussion.

We will never know why Geoffrey combined Blue Jay and anteater as a single bird-animal, then imagined the hybrid battling a dragon. We can imagine that this is comparable to the formation of myths in ancient cultures. Fantasy is common enough in children for us to suggest that self-made myths and imagined heroic figures are essential to a well-balanced psychology, whether at the personal or social level.

Figure 8.1 *The Blue Jay-anteater* by Geoffrey, age 4.

Balancing aggressive and non-aggressive themes

We wonder why boys favor battle scenes in their imaginative play. (War drawings by girls are rare, although a colleague once showed me one by a girl who had experienced war personally. Based on real and tragic memories, her images contained no element of fantasy.) It may be that war and hunting and fighting are rooted in the male's collective unconscious. There is certainly a mythical significance for boys. Girls, on the other hand, rarely draw images of violence, reinforcing the view that, biologically and traditionally, they are nurturers.

Or it could be simply that boys' interest in violence has cultural origins. Violent imagery abounds in media

Figure 8.2 *Little Nites* [Knights] by Blake, age 7.

Figure 8.3 *A Scene from Peter Pan* by Benjamin, age 6.

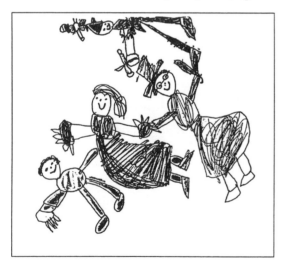

fantasies, and boys are usually the combatants. Geoffrey's family is harmonious and television is restricted, yet he loves to draw armies preparing for battle. Should we be alarmed when children choose violent themes? Is it an indication of violent tendencies or are they out of touch with reality? Psychologists are more likely to be concerned when children are unable to fantasize. An active imagination is important to the development of a creative and fully self-actualized person. Normally, violence in drawings can be accepted as a safety valve.

Parents and teachers can do much to achieve balance by motivating non-aggressive themes.

When four-year-old Geoffrey was making drawings like *The Blue Jay-anteater*, he was also going with his mother on daily walks, where he was introduced to the empirical methods of science. He carefully observed flowers, birds, trees, and animals and, with her help, made observations in his journal. He was thus encouraged to empathize with the natural environment, to grow up responding both to personal fantasies and to the real world of home, community, and nature.

As a teenager, fantasy continues to motivate Geoffrey, but the interface between fantasy and reality is well-established. He seldom draws from memory or direct observation. This is generally true for his age group. Drawing real experiences would help him maintain a healthy relationship to his community and the natural world. It would be helpful if parents could look to the schools to redress this common imbalance. Teachers are in a much better position than parents to schedule drawing from memory and observation.

Figures 8.2 - 8.5 are examples of drawing from imagination. Figure 8.2 was sent to me by Blake's teacher, who wrote the following report: "Blake loves to draw fencing matches and this began as one but he made a mistake with the

knight on the left. His padding looked wrong so he made it into a cup! He went with that thought and it became a battle scene of dishes in the dishwater!"

A letter to the Drawing Network from Benjamin's mother came with his drawing (figure 8.3). She wrote: "For the last five years, I have experienced the wonder of watching my child explain his world through drawing, making marks with pen, crayon, or felt. He stretches out on the kitchen floor daily with his sketchbook in front of him, pen in hand, and he draws his life. When he was first introduced to Peter Pan and Captain Hook, he drew pictures of himself as Peter Pan, as Captain Hook, as John. His little sister became Wendy, or Michael the baby."

As part of a unit on Greek myths, Sandra drew Neptune (figure 8.4). She used impressionistic rather than classical lines to show the god intermingled with the flow of water and the tumble of waves. Look for exquisitely placed logs on the pebbled beach and a tiny trident, symbol of Neptune/Poseidon.

Byron's drawing (figure 8.5) reveals his love of movies, especially those with monsters like King Kong. He has a flair for graphic design, and his drawings look like movie posters.

Fantasy themes are not only commonplace with young children, but also with post-naives of all ages. Consider the content and popularity of films, video games, comic books, science fiction novels, and advertising. Are these flights from reality, emotional escape valves? It may help to distinguish between the consumption of fantasy (as in sitting in front of the television) and its invention (as in imagining and drawing monsters and mayhem). Perhaps the objective of educators and parents should be to help young people find a balance.

Figure 8.4 *Neptune, God of the Seas* by Sandra, age 11.

Figure 8.5 *The Never ending Story* by Byron, age 8.

The two drawings by Stefan (figures 8.6 and 8.7) show fantasy imagined by a pre-teen boy. Stefan's father, an artist, takes a lively interest in his son's work, and wrote to me: "Stefan has a very lively imagination ...his drawings are like a cascade of endless thoughts and ideas. He is intrigued by my drawings and paintings and is not deterred by his perceived lack of skill or training from trying to draw or re-create or mould his own fantasies or give visual (or musical) expression to his own feelings whether they are anxiety or exhilaration or frustration or whatever."

Apocalyptic Vision (figure 8.7) does not mythologize or glorify war but describes it as a catastrophe spanning millennia. We appreciate the irony of Stefan using the same form for modern rockets and ancient arrows. Although he depicts chaos, his design is controlled by an intuitive understanding of form. Now fifteen, he still draws constantly and his skills continue to develop. His current themes are consistent with the work shown here.

Erika's *Farm Scene* (figure 8.8) may have been inspired by a romantic story of farm life in olden days. It is far removed from Stefan's content, and speaks to the differences noted earlier in boys' and girls' choices in drawings done from imagination.

More About Visualization and Guided Imagery

We have discussed visualization and guided imagery before, but because it is so important to drawing from imagination, I continue it here.

Figure 8.6 *The Dream Airplane* by Stefan, age 11.

Figure 8.7 *Apocalyptic Vision* by Stefan, age 12.

Pictures on the 'inner screen of the imagination' appear as fleeting fragments, impossible to hold for more than a few seconds, but long enough to begin a drawing. Once the pen starts to move, other influences come into play: the materials, the drawing process, memories, and drawing skill. All combine to capture and transform the ephemeral image. Having an image on the inner screen is not always necessary: graphic equivalents of thoughts and feelings sometimes make their way directly from the pre-conscious to the paper. Perceptual feedback from the drawing guides the process.

Figure 8.8 *Farm Scene* by Erika, age 11.

Motivating drawing through visualization and guided imagery

A class may be motivated to draw from imagination by having a teacher describe a theme, a famous work of art, or a photograph. The children shut their eyes and make mental notes. They know they are planning a drawing, so they pay close attention to detail. The teacher points out that pictures on the 'inner screen' are quick to fade, but this should not worry them. Some may claim they can't 'see' anything, and the teacher will have to exercise patience. They are assured that they are not expected to copy the image exactly; visualization is for stimulating drawing.

Figure 8.9 *Ice Cream Man*
by Richard, age 11.

It is also for making passive knowledge active, accessing the preconscious, and assembling relevant details. As always, how much the teacher tells children will depend on their age and background.

Guided imagery can be used to establish a point of view. Consider saying to your students,

> *A forestry worker is cutting down a tree with a chain saw; imagine you are a bird looking down on what is happening...Now change the point of view: imagine you are a small animal observing the action from ground level.*

Guided imagery can help to organize pictorial elements. Use guided imagery to find different ways of organizing the picture on the paper. After a story has been read and visualized, say to the students,

> *We have visualized the story; now, let's visualize how your drawing will look. Suppose you place the castle some distance away from the knight and his horse. How will that look in your drawing? Can you visualize how the knight's figure will overlap part of the landscape, maybe even part of the castle? Are the knight and his horse completely visible, or are they so close that only the upper parts can be seen? Now let them get closer to the castle; what do they look like? (Remember, it's the drawing you are looking at!) Now, can you place yourself in one of the castle towers? The knight is off in the distance. What does he look like? How will you organize your drawing from that point of view?*

Imagery to motivate perspective. In the last chapter, we saw how guided imagery was used to teach perspective by having the drawers imagine a Hallowe'en scene. The drawing at figure 8.9 draws upon self-guided imagery or visualization. I don't know the origin of *Ice Cream Man*, except to say that I believe it to be Richard's own invention. He may

have learned that 'things appear smaller as they are farther away' from drawing lessons, from comic books or television cartoons. His drawing shows a fascination with this phenomenon and he puts it to good use.

Imagery can lead to the comic book format.
Slaying the Dragon (figure 8.10) illustrates sequence drawing from imagination. In the first panel, a knight stands guard at the entrance to the castle and a dragon appears below. In the second, the dragon leaps up but is cut down by the knight. In the third, the knight signals his victory. Through guided imagery, teachers can help children focus on a narrative sequence which is then translated into a series of images. A common use of sequence drawing results in comic strips, that have long used the convention of 'thought balloons' to tell us what characters are thinking. In *Joseph and Mary* (figure 8.11), Blake uses this device to show that Mary is thinking about her baby, and Joseph is thinking about a place for his family to stay for the night.

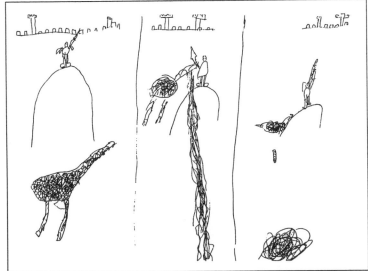

Figure 8.10 *Slaying the Dragon* by an anonymous primary boy.

Figure 8.11 *Joseph and Mary* by Blake, age 6.

Teaching Ideas Based on Drawing from Imagination

Fly over an imaginary landscape. Take children for a walk over visually stimulating terrain. Ask them to pretend they are flying in a small airplane. What do they see below? How are ordinary plants, insects, bits and pieces of scrap, transformed? Later, back in class, have them do drawings based on what they have imagined.

Try the Blue Jay-anteater strategy. Introduce a study of mythical beasts such as the griffin and the sphinx, describing them from book illustrations. Have the children draw

using visualization and guided imagery. Later, have them research mythical creatures in the library and make drawings from memory. The children can design original combinations of birds, insects, animals, plants and transform them into masks and costumes to use in plays they write themselves.

Draw historical battles. The popularity of drawing war scenes can be harnessed in social studies. Have students research historic battles and make drawings from imagination. The details should be as correct as possible. (See Chapter Nine.)

Illustrate favorite books. Children enjoy illustrating their favorite books. Often their drawings contain elements of fantasy, as we see in Benjamin's *A Scene from Peter Pan* drawing. Others like to draw how people lived in different times and places, as in Erika's *Farm Scene*. Select episodes from favorite books then, after visualization and guided imagery, ask the children to draw the imagined scene. Isadora's *House in the Woods* (figure 8.12) was inspired by *Seeds*, a quartet of stories by Brian Moon.

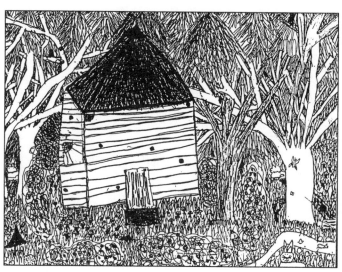

Figure 8.12 *House in the Woods* by Isadora, age 11.

Make entertainment posters. Using Byron's *Never ending Story* (figure 8.5) as motivation, have the class make drawings based on their favorite television show, movie or book. Make posters in art class using both images and words.

Draw dreams and invent dream-like images. Stefan's work has a dream-like quality (figures 8.6 and 8.7) although he doesn't draw his own dreams. Challenge children to either draw a dream or make up a visual story dream.

Use 'thought balloons.' Tell children they can use 'thought balloons,' as Blake did in figure 8.11 to tell us what their characters are thinking or saying. A balloon made of dots

or scalloped edges is for unspoken thoughts; a balloon with a smooth, unbroken line is for spoken words.

Drawing From Memory

There are two kinds of memory drawing: first, an object or person is studied just prior to being drawn, which we will call programed memory drawing; and second, events from the past are recalled. This is called significant event memory and a subsequent drawing captures an event and gives it special recognition. Encouraging a reflective response to real people and real events adds meaning and emotional significance to our lives.

Programed memory drawing: Kim's game

Programed memory drawing is based on Kim's game from the novel *Kim* by Rudyard Kipling. In the story, a strategy is described for training British Foreign Service spies to observe and remember details. A tray of objects is studied and then removed from sight. The observer is required to remember and list as many items as possible. This involves concentration, perceptual acuity, and retention of details.

If we adapt Kim's Game to drawing, we have the children briefly study a single object and trace its contours on the desk or in the air with the forefinger. Eye and finger movements are coordinated. When the forms have been memorized, the object is removed and a drawing is done. This technique can be adapted for drawing humans, locations, and so on.

In another variation, each student is given a small complex toy in a paper bag. On a signal from the teacher, the object is removed, studied, and memorized. Students return the object to the bag and make a line drawing. They then exchange bags and repeat the performance.

In a South Park classroom, ten-year-olds played Kim's Game and made drawings of microscopes. Students carefully studied the objects, then the teacher removed them from view. The following monologue describes how this teacher motivated the drawing:

On each of your desks you will see a microscope from our science room. It looks hard to draw doesn't it? I want you to look carefully at all the edges of the forms: run your fingers over them as I'm doing. Every edge is a contour and drawing contours is the secret of programed memory drawing and drawing from observation. Microscopes are fairly complicated and have complex forms. You might think it would be easier to draw oranges or something else round like an egg. You would be wrong: round objects generally have only one contour: you would have to use shading to give them form. Believe it or not, complicated forms are easier and certainly more fun to draw. Look again at the intricate parts of the microscopes and how they work together so efficiently. Enjoy the beautiful patterns they make. Study the contour edges and remember that each edge will be transformed into a line contour. Study and memorize the form until I ask you to put it away and then draw it.

Figure 8.13 Programed memory drawing of a microscope by a ten-year-old.

Drawing from memory using posed figures

Hallowe'en, with its costumes and drama, is an excellent basis for drawing. The South Park teacher used the day to motivate the following.

We have been studying small complex objects before drawing them. Today we are going to use the same strategy to draw two figures in a Hallowe'en pose. Study the subject and draw it from memory using continuous classical line. I've arranged for John from Mr. Smith's class to visit us in the costume he'll be wearing tonight. We'll pretend that he's knocking on the door calling out,

*'trick or treat!'. Then I'll answer the door. We'll pose for a
few moments and then John will go back to his room.
Your job is to study the pose carefully and draw it from
memory. We'll use game drawing technique.* (See
Chapter Seven.)

'KIM'S GAME' ON A FIELD TRIP

On another day, an out-of-school walk provided the
motivation to draw.

*Today we are going to visit the little store across the
street from the school. We have all enjoyed the flowers
displayed on the sidewalk. When we get there, I want
you to observe the store carefully, and when we return to
the school, we will do contour line drawings. I have a
suggestion: while studying the forms, draw them on the
palm of your hand with your forefinger. This will help
you memorize the contour edges.*

An alternative method of using the 'posed figure' strate-
gy is the following: As a focus for discussing the roles of
women in the lives of children, a teacher showed his class
a large reproduction of *Walking Woman* by Michael Snow.
They talked about the image and students were encour-
aged to incorporate the form into a personal memory
drawing. Later, when they did drawings, Jon chose to draw
his mother mowing the lawn (figure 8.14). Her contented
face, the warm sun, the care with which he delineated the
houses and applied tone and texture, all communicate feel-
ings of admiration and affection. His picture celebrates the
routine chores that filled his mother's day.

Figure 8.14 *Mother Mowing
the Lawn* by Jon, age 11.

Special event memory drawing

Memories of special events such as seasonal festivals,
holidays, a birthday celebration, a visit from an important
relative, or a field trip, make good drawing subjects for

Figure 8.15 *Memory of a Ferry Trip* by Jessica, age 8.

Figure 8.16 *My Bedroom* by Zoe, age 6.

children. An exciting part of a ferry trip is meeting another ferry going in the opposite direction. The drawing at figure 8.15 shows how Jessica remembered the experience from a field trip.

In planning memory drawings, certain factors can influence how well we remember:

Repeated exposure. The more familiar we are with anything, the easier it is to remember. In anticipation of doing a drawing, children are asked to study details they might otherwise overlook. The following teacher's monologue inspired Zoe's picture at figure 8.16.

This next drawing project requires planning on our part. Later in the week, I'm going to ask you to draw your bedroom, probably the room in your house you know the best, from memory. This is designed to help you improve your observation and memory skills. Include all the details you can remember. When you go home tonight, stand in the doorway of your bedroom, or in a corner of the room, and make mental notes of everything you see. Don't write them down, just make a mental list. Do this several times in the next few days so your memory will be strongly reinforced. You might include the view from your window to make the drawing even more interesting.

Familiarity. Throughout the history of art, we find drawings of ordinary objects (Vincent Van Gogh's shoes) and everyday activities (Mary Cassatt's mother bathing a child). Memory drawing allows us to isolate and illuminate fragments from our lives. In this strategy, students are asked to make a drawing based on such an experience. Here is one teacher's instructions.

We all have routines to follow. Some of us may wash

dishes every night. Some may babysit regularly or deliver papers. Think about a routine in your life, some chore you do every day. Then follow the steps I have written on the board.

1. *Choose a routine chore or situation.*
2. *Visualize it and use guided imagery to watch yourself performing the task from more than one point of view.*
3. *Choose a point of view and visualize it again in more detail.*
4. *Visualize what the drawing will look like in general terms and organize the components.*
5. *Make the drawing.*

Association. A single detail can release a flood of memories and may lead to the reconstruction of a past experience. Memory can be stimulated by a smell, a song, a story, an old photograph, and so on. In this variation of encouraging kids to draw from memory, the teacher hands out envelopes that contain fresh pine needles. She tells them

You will find an envelope on every desk. Don't open it until I give the word. Have you noticed that a pungent smell has the power to bring back a particular memory? Sometimes we like a smell for the rest of our lives because it has pleasant associations. I love the faint whiff of asphalt because I associate it with my first visit to a large city. In the envelope, you will find something to rub between your fingers to release a perfume. Put it close to your nose and shut your eyes. You may remember a pleasant time on your holidays. See what comes up on your 'inner screen' and make a drawing of the memory.

Emotional intensity. Events charged with emotion are remembered longer than others. Memories live on because they record happy occasions, peak experiences, personal tragedies, and sorrows. They may have to do with the people we have loved and lost, quarrels we have had, or rifts

we have healed, getting a pet or losing one, our first experience of death or of falling in love. Other themes might be a ghost story that really happened, performing for an audience for the first time, finding something precious, helping someone and feeling good about it, discovering a new friend, losing an old friend, going to the hospital.

Drawing From Observation

Having children draw from observation is relatively rare. It is considered lacking in creativity, unsuited to their neuromuscular development, of no interest to them, and simply too academic. Yet kindergarten children can show great interest in drawing visible models. You will share my excitement when you see, later in this section, the drawings done by a class of kindergarten children in the Museum of Anthropology.

There are good reasons for introducing drawing from observation as early as possible. We should remember that children first draw real people and real things, not fantasies. Why should we hesitate to motivate them with real models so long as teaching methods are appropriate and it is part of a balanced program?

With young children, I prefer the term drawing with the model present or drawing something we can see. Drawing from observation suggests that what is observed is checked constantly against the drawing on the paper. I doubt that this is how younger children work. For them, the model is stimulating, but unless there is adult pressure to draw 'correctly,' they will approach it as they would any other drawing, that is, spontaneously from memory.

My colleague at UBC, Professor Michael Foster, supervised children's art classes taught by student teachers. He would arrange for a parent dressed in ethnic costume to pose, perhaps with a baby. Once the children had been

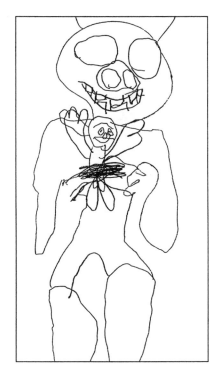
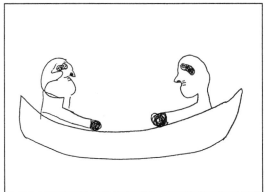

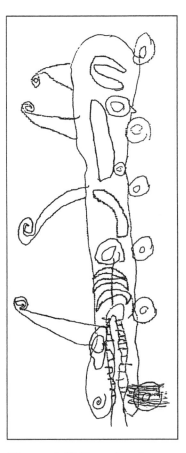

Figure 8.17 Four drawings done at the UBC Museum of Anthropology by kindergarten children.

motivated by the subject and grasped the essential forms, they tended to ignore it and focus on their drawing. The subject would remain in place as a continuing source of inspiration.

It is, of course, important not to evaluate the child's efforts in terms of naturalism or photographic realism. One six-year-old proudly took his painting of a lion home to his parents. His dad showed interest, and, trying to be helpful, brought out the encyclopedia and said, "Now, let's see what a lion really looks like." The child's mother reported an almost immediate and entirely understandable decline in the boy's interest in drawing.

Drawing at the Museum of Anthropology

A kindergarten class was taken on a field trip to the Museum of Anthropology as part of a study on West Coast

native culture. A First Nations woman had visited the classroom and talked about the legends of Bear, Raven, and Killer Whale, and introduced them to native crafts, songs, and stories. They had been told about the carving techniques and stylistic characteristics of totems. They took clipboards and drawing materials to the museum and their teacher suggested they draw whatever interested them. This was the extent of their instruction.

They scattered and did the drawings in figure 8.17 (page 117). No one complained that the subjects were too hard; no one said, "I can't draw." Later, their teacher sent this report to the Drawing Network newsletter:

> *It was natural for them to take along paper and a sketch pad to discover what symbolic characters they could recognize on totem poles. Totems tell special stories about the relationships between animals and people. For example, the hulk of the bear form can be appreciated as an all-powerful protector of man who is frail and small. The children recognize the impact of such a carving for they too know what it is like to feel loved, secure, and protected by someone/something bigger than themselves.*

These drawings are not what we usually think of as child art. They don't fit the developmental categories discussed in Chapter Three; indeed, they amaze us with their realism. I have taken adults to draw the same carvings. Astonishingly, the best of the kindergarten drawings would not be out of place in the folio of a beginning art student.

The approach of my adult students and that of the kindergarten children would, of course, not have been the same. Adults usually discipline themselves to keep their eyes on the subject while following contours. They make frequent checks for accuracy. This creates anxiety and their hands don't respond easily to what the eye observes. In contrast, children observe the model and then tend to draw from memory, keeping their eyes on the paper.

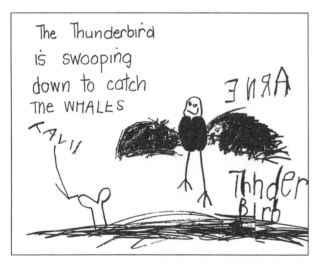

Figure 8.18 *The Thunderbird is Swooping Down to Catch the Whale's Tail* Drawing of a native legend by Arne, age 5.

Arne's drawing (figure 8.18) is typical of what we would expect from a kindergarten child. Back in the classroom, after the museum trip, more drawings were made. Arne used a combination of words and images to show his version of a native legend. The teacher discussed his drawing with him. Together, they came up with a descriptive sentence which the teacher printed in an empty space. Arne added words of his own. Reading, writing, printing and drawing contributed to a rich language experience.

In the museum, the children had studied the ovoid forms typical of West Coast carvings and later practiced cutting them out of black paper. While drawing an ovoid would be challenging, it was managed more easily with scissors. The cut shapes were glued to paper and the drawing completed with a fine-tipped felt.

Raven Bird (figure 8.19) harks back to the origins of language: words chanted to summon spirits or animals, or graphic images drawn in caves. When the First Nations friend came to visit, she introduced them to chanting. The child who drew *Raven Bird* added words of her own as a sort of visual chant. It can be read from top to bottom like a musical score, getting louder as the words get larger.

More drawing with the model present

When teachers emphasize the values of expression, feeling, ideas, and interesting form over verisimilitude, drawing from observation becomes a rewarding experience at any age. Figures 8.20 - 8.23 are examples of drawing from observation.

Marcus attended private art classes. One day, the children were prensented with a beautiful vase of flowers to draw. After a class discussion to motivate them, the teacher left the students on their own. Marcus drew figure 8.20.

Figure 8.19 *Raven Bird* by a kindergarten child, age 5.

Figure 8.20 *Flowers in a Vase* by Marcus, age 7.

Figure 8.21 *Portrait of a Friend* by Edward, age 10.

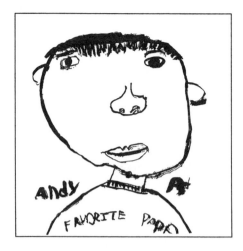

Figure 8.22 *Portrait of a Friend* by Andy, age 10.

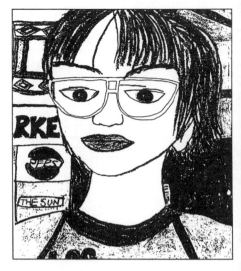

Figure 8.23 *Self-portrait* by Bernice, age 9.

Figure 8.24 *Anatomical Study* by Howie, an intermediate student.

Edward and Andy drew portraits of each other using Chinese brush and ink (figures 8.21 and 8.22). Bernice, from the same class, chose to do a self-portrait (figure 8.23).

Older children drawing from observation

Drawing from observation is one way to help older post-naives overcome self-consciousness and gain control over form and expression. They are more concerned with getting a convincing likeness, as Howie was in his skeleton drawing (figure 8.24). Some erasing may be helpful in projects like this. Artists' B-lead pencils, hot-press paper with a hard, glossy surface, and a good quality eraser are the correct materials. The drawing proceeds in two stages: first, a light, soft line is used which can be erased easily; second, a stronger line is applied to make corrections and to finish the drawing. The eraser is used to take out unwanted lines.

Drawing difficult subjects from observation

Grade four and five children were asked to draw eggbeaters and microscopes and later, a saxophone, from observation, objects deliberately chosen for their complexity. This was a new experience since they were accustomed to illustrating stories and events from memory and imagination. How would they react? Would there be empathic identification with subject matter? Would it carry over to drawing empirical subjects in science and social studies? Would it build confidence at a time when it was beginning to decline? My summary of the teacher's report, sent to the Drawing Network, combined with my own observation, follows:

- The project was greeted with mixed feelings but pupils trusted their teacher and faced the challenge with a positive attitude. Brief written responses indicated that some enjoyed it and others didn't. If drawing from observation became a regular activity and skills improved, it would probably give more satisfaction.
- The drawings indicate that the subjects were carefully observed and accurately drawn. As well, the images have an animistic presence associated with empathy. Perhaps this is because complex objects require more concentration.
- By the time they reach the intermediate years, children are rooted in the subjective world of early childhood, but are also reaching out to the objective world of the human and natural environment. Drawing from observation contributes greatly to this transition.

Figure 8.25 *Microscope* and *Eggbeater* Two drawings from observation by intermediate children.

Figure 8.26 Four drawings of a saxophone, by intermediate age children.

For most of us, even experienced artists, drawing saxophones would be considered a challenge. This collection of saxophone drawings (figure 8.26) shows that intermediate age children can learn to draw even a most complex subject.

Figure 8.27 is one example of a number of sunflower drawings that came with this report from an intermediate teacher:

One sunny September 12th we carried a couple of benches outside and sat down to admire and draw one particular sunflower that the children had planted in their Centennial Garden. It was not quite ready to burst into its full open display. I think the drawings show the strong suppressed ready-to-burst energy of the subject. This flower was tied to the fence but ended up folding over under its own weight. We took it in to paint on full-length pieces of paper. What a beautiful mural it made!

By observing carefully and drawing with empathy, children make startlingly lovely images of visible models. When they draw what they see and touch, beauty is found in ordinary things which then become extraordinary. In reaching out to 'touch' the sunflower in the act of drawing it, drawer and subject merge in a new entity, drawer-sunflower. Drawing from observation becomes a healing therapy as ego is joined with a reality beyond. The strongest argument for drawing from observation may be that we are able to experience the world empathically as a unity of self and other.

Figure 8.27 *Sunflower*
A drawing from observation by an intermediate student.

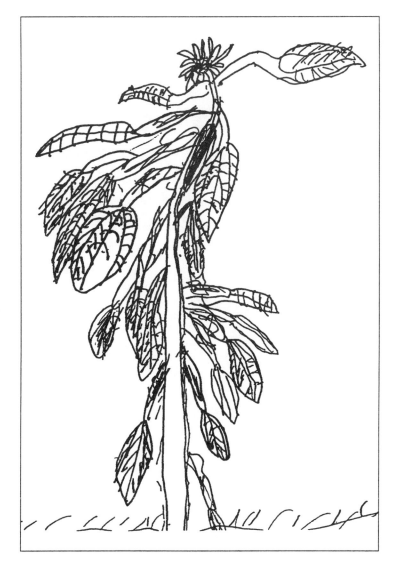

Drawing in Science, Social Studies and Art

Our goal is to encourage teachers to use drawing in the core subjects when it seems an appropriate medium and to urge parents to accept drawings by their children as a form of language or communication. To remind ourselves of its value in empirical studies, we review some points.

- Children use drawing to process information, articulate ideas, and solve problems.
- Drawing sharpens perception: before intuitive insight is possible, information must be gathered. The sciences and social sciences depend on information which, in turn, depends on perception.
- Children use drawing as a tool of analytical thought. Learning to observe carefully leads to the understanding of relationships, to thought-provoking questions and reasoned analysis.
- Drawing helps children establish empathic relationships with the natural world and the human community. The process begins at home and continues at school. If drawing is integrated into science and social studies, empathic relationships continue to form and expand to embrace neighorhoods, then communities.
- Because of its spontaneity, drawing is the best language for encouraging inventiveness and imagination. It is

easier for children to draw an invention than to describe it in words. Diagramatic drawing with words added is an ideal combination.

Nature Walks and Neighbourhood Walks

Observing and taking delight in the natural world, and exploring one's community with parents, teachers, and friends, are the beginnings of science and social studies for many children. Education in science and social studies begins at home. Young children learn to converse and drawing emerges as a potentially useful language. Children's curiosity about all things means they are increasingly interested in community and nature.

When Geoffrey was four, his mother took him on daily walks. Returning home, they made entries in a diary about what they had seen. Here is one entry called "Going Out and Looking at Stuff."

> On February 26th we went for a walk to look for birds and other interesting things. It was raining a bit but we had a good time. We took binoculars. We saw a seagull, two crows, two medium-sized birds, three sparrows, two dogs (Casey and Finnegan), and a bird's nest. We saw two pink flamingos and we thought we heard an owl hooting. Geoffrey found two hanging pots with fuschias in them. They were dormant. We found some holly, snowdrops, tulip shoots, purple, white, and yellow crocuses, rhododendrons, and two all-coloured rocks. Then we came home.

Primary school children in Likely, BC are regularly taken on nature walks. Visitors from the community and from faraway places come to the school to talk about their special interests, cultures, and homelands. Students report in the class paper, *Primary Press*.

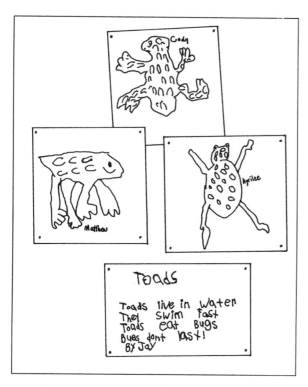

Figure 9.1 Three drawings of toads and a poem by primary students.

We started off with a walk to the creek. We caught water bugs, and went wading. Some of us (especially Erik and Josh) got a bit wet. Erik caught so many water bugs he offered to share some with Ayrilee's sister Holly. We looked at a beaver dam, but we didn't see any beavers.

Our illustrations today come from a visit on Monday by Mrs. Olsen. She brought in a big toad for Show and Tell. We all got a chance to look at it closely and some of us drew pictures of it. We wrote a poem to go with it (shown in figure 9.1).

In the afternoon we had a visit from two people who live in Australia. Karen and Malcolm brought in a short video showing the place where they live. They have a waterfall they can swim under. We saw pictures they had taken of animals that only live in Australia.

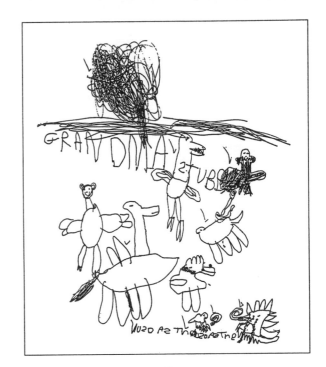

Figure 9.2 *An Australian Zoo* by Thomas, age 4.

Thomas spent a year in Australia and, after visiting the Melbourne Zoo, made a drawing of it for his grandparents in Vancouver (figure 9.2). He wanted to tell them as much as possible about what he saw there, and his drawing is filled with information. Drawing is an effective way for children to process (record and pass on) information. Perception, cognition, feeling, empathy, and imagination are all essential to good science and effective social studies.

Figure 9.3 *Fishing Boat* by Gerry, age 10.

Drawing to Sharpen Perception and Increase Knowledge

Drawing technical things

Gerry made a diagramatic drawing of his father's fishing boat (figure 9.3). His teacher was impressed and sent me a selection of his drawings. He wrote, "These are Gerry's doodles on the back of a math sheet. He was born and brought up on boats. He's ten and

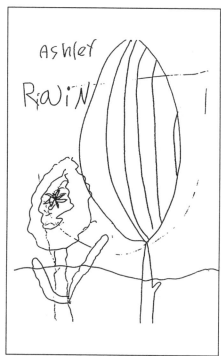

Figure 9.4 Two Flower Drawings by students in Likely, BC.

knows all there is to know about the ocean and boats!"

'A picture is worth a thousand words' is emphatically true in particular learning situations. The anatomy of an animal, the parts of a machine, the art and architecture of a people, are areas of knowledge well served by drawing. Gerry draws his dad's fishing boat graphically, and he should be encouraged to talk and write about it as well. Children like Gerry should be encouraged to share their valuable resources of technical information with the class. All children with special gifts and interests can increase their own depth of knowledge, improve their communication skills, and contribute to the education of others by undertaking projects like the following.

- Have students turn original drawings (such as Gerry's) into overhead transparencies for a class presentation. Additional drawings may show some parts in greater detail.
- If students learn something technical at home, such as how to put air in a bike tire, make soup, deadhead flowers, sharpen a tool, and so on, have them illustrate and write a concise description for a class presentation.

Drawing flowers

Drawing plant forms is a good way of learning to observe carefully and draw accurately. The children in Nadine Guiltner's class of Likely, BC, gathered flower specimens and brought them to school to draw (figure 9.4). Later, she wrote:

> We are busy using our drawing books. One day we had a whole afternoon of flower drawing. Each student had a different flower. At first we just looked at the flower, then we took it apart to see how it was made. Some of the flowers had seeds, so we took them out and studied them using magnifying glasses. We talked about different leaf,

stem, and flower shapes. Finally, we each got a fresh flower and did our drawings. It was a lot of fun, and we certainly learned a lot about flowers.

Drawing marine life

A marine biologist was invited to bring samples of sea life to the school and talk about them. Various specimens were studied and line drawings made (figure 9.5). A few days later the class took a beach walk with their teacher and the biologist to examine tidal pools and the sea creatures who lived in them. Drawings made on the spot were used to sharpen perceptions and record observations. Consider the ways language was essential to learning throughout this project: the children listened to the visitor, made notes, asked questions, described phenomena, formulated and tested hypotheses, and wrote about their findings.

Drawing an amphipod

Kate, age ten, observed the forms of the amphipod carefully as she drew it (figure 9.6). Her extraordinary hand/eye coordination may be due to the empathy she felt for her subject. Her response to the beauty of natural forms is something she will carry with her into the future. The proportioned arrangement of the amphipod's armored plates is captured exquisitely in line. The functional and aesthetic elegance of this sea creature would have been beyond her power to describe in words. When children draw, they are moved by curiosity, feeling, and the pleasure of seeing.

Figure 9.5 *Two fish and a crab* by an intermediate student at South Park Family School.

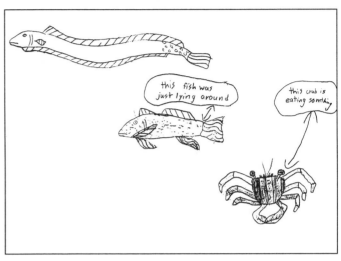

Figure 9.6 *Amphipod* by Kate, age 10.

Drawing to Increase Understanding of Our World

We have been concentrating on drawing real subjects from observation in science and social studies, but memory and imagination are also important. Laura made this drawing of weather based on experience and on the illustrations in the books her parents read to her (figure 9.7). She was taking a first step toward scientific thinking. This drawing, photo-copied as a class set, would be useful in motivating children to do weather pictures. We might ask, "How many things can you see in the picture having to do with weather?"

Figure 9.7 *Windy Stormy Lightning Day* by Laura, age 5.

Drawing the seasons, nature and space

A theme about the seasons is another science topic that children can illustrate. Cory divided a landscape drawing into four sections, each quarter devoted to a season (figure 9.8). This could be used as the format for a class mural.

Kate was inspired to draw a stream, trees, pebbles, insects, fish, birds, and animals, all from memory and imagination (figure 9.9). Some of her creatures were hiding in trees, perhaps to illustrate protective patterning. The class had been studying the balance of nature and the cycle of life.

Figure 9.8 *The Seasons*
by Cory, age 8.

Figure 9.9 *Nature Drawing*
by Kate, age 8.

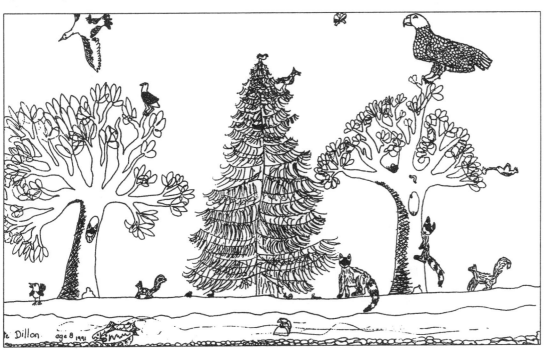

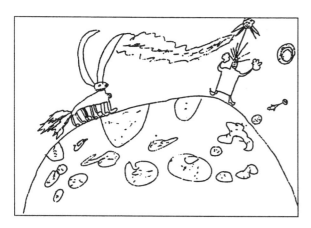

Figure 9.10 *Space Dog Going to Blast Off* by James, age 7.

James did several drawings within a day or so on the subject of space. They were about spaceships and their crews, other planets, and the strange creatures living on them. Typically, he organized forms on baselines. In the first drawing, a tiny round spacecraft creates the illusion of distance. James knew that things farther away appear smaller and used that knowledge to show perspective. He dictated lengthy captions to his mother. For figure 9.10: "Space dog going to blast off space monster. If he wants to talk to somebody, the bird on the top of his head talks and the space monster hears it." And for figure 9.11: "Earthling space ship...earth spaceship...in between there are fake bombs to scare people off."

Drawing to Solve Problems and Invent Things

When children draw to design engineering projects, architectural fantasies, defence installations, spaceships, and so on, their intellects are actively engaged. This activity, frequently self-motivated, should be encouraged since the creative thought patterns needed to solve problems are established in childhood. David spent hours working on *Water Treatment Plant* (figure 9.12) and drawings like it. He rarely added words, but his mother asked him to describe this one when it was finished.

Figure 9.11 *Earthling Space Ship* by James, age 7.

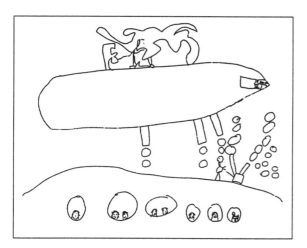

> *It's a water reserve and it gets the water from the rain and the rivers. Then it gets cleaned out and then they put (it) on the truck. And then it gets taken to the reservoir. And when it's all collected it can go into the pipes, into the taps. People stay around the reserve 'cause they do the work. The toilets are one big building and the stoves are in both buildings and the smoke goes down to a muffler. Then the smoke comes up in the air. It goes towards the water. Then it gets stopped.*

Figure 9.12 *Water Treatment Plant* by David, age 7.

Edwin uses his father's mechanical drawing instruments for precise renderings of transportation fantasies, military vehicles, and postmodern buildings (figure 9.13). This raises the question: should children be allowed to use rulers? The simple answer is: when straight lines are required, a ruler is the best way to get them. On the other hand, depending on mechanical tools is likely to diminish expressivenss.

Figure 9.13 *City Plan* by Edwin, age 8.

Figure 9.14 *Microchip Changes Into a Robot* by Nicholas, age 9.

Transformation drawings

A popular maxim has it that today's science fiction is tomorrow's science. Perhaps this is a reason for encouraging children to draw space-age fantasies and futuristic inventions. Nicholas spent hours inventing ingenious machines that can be transformed like the popular toy. He wrote this about figure 9.14: "Big robot microchip changes into a robot and fixes the big robot (on left). Microchip is actually part of the big robot."

Teaching Ideas Related to the Transformation Theme

The dream of transformation has resurfaced in modern technology in ways not dreamt of by medieval alchemists. Toy transformers may be an outmoded fad, but their theme is timeless and offers many teaching possibilities.

- Have children bring transformer toys to school and make a series of drawings showing the stages of transformation. Several formats may be considered: all the drawings done side by side on one piece of paper without boundaries (sequence drawing); or each isolated in a box, comic book style; or superimposed, one over the other, each in a different identifying color.
- Challenge the children to invent new transformer toys by drawing them.
- Have the class research transformation myths; examples abound in Greek, Inuit, Coast Native and other cultures. Have them rewrite these stories in their own words and draw the transformations using the formats described above.
- Have children write an original story about a magic transformation and then design and make masks to

illustrate it. They might write a play based on the story and present it to the class.

- Have children draw toys and show them being transformed into human characters, animals, birds and plants, using the formats described above.

Brainstorming

In brainstorming, ideas are tossed about without much concern for practicality. On a chosen topic, each student contributes his or her view of the problem and how to solve it. Then each student develops a detailed solution by doing a drawing, using words and numbers as needed for explanation. They then transfer all their solutions to a large sheet of paper taped to the blackboard to make a mural.

South Park Family School regularly schedules time for problem solving. One class had been reading a story by Heidi Chang about frogs and, at the same time, studying flying objects in science. Students asked if they could combine the two themes and brainstorm ideas for getting frogs to fly. Figure 9.15 shows one child's plan.

One student was confined to a wheelchair and had trouble getting through doors. Her classmates were asked to design a tool to help her (figure 9.16). The teacher described the strategy as follows.

First lesson: The class brainstormed problems and made a list. They categorized them under headings: school, home, environment, entertainment. They were then asked to choose one problem and draw an invention to solve it.

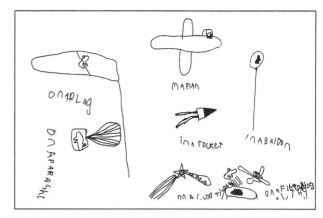

Figure 9.15 *Flying Frog* by a primary child inventing a way for frogs to fly.

Figure 9.16 *How to Open a Door from a Wheelchair* by an intermediate student.

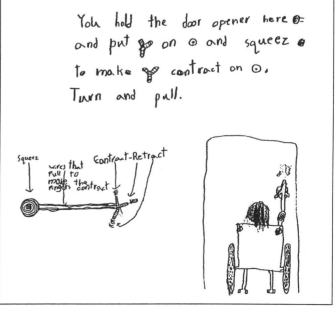

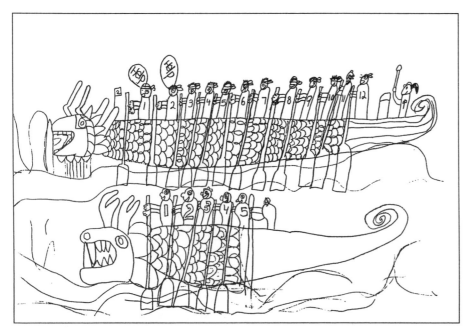

Second Lesson: Students were asked to design a mechanical device so the wheelchair-bound student could open doors. I challenged them to take turns in her wheelchair going to a closed door, opening it, going through, and closing it behind them. Then they had to invent an all-purpose door-opener that could be carried around in a handy way.

Celebrating Community

Figure 9.17 *Dragon Boat Race*
by Marcus, age 5.

Children should be encouraged to learn about the traditions brought to Canada by their parents and grandparents, and to share them with classmates. Writing and drawing about family customs, myths, stories and ethnic festivals celebrate diversity in a common humanity. Marcus was taken by his parents to see the annual Chinese dragon boat races in Vancouver. He made the drawing at figure 9.17 from memory.

Figure 9.18 *Buses*
by Marcus, age 5.

On another occasion, Marcus drew four buses (figure 9.18). Many aspects of urban life make good research topics, such as transportation, firefighting, health care, urban planning, heritage preservation, police protection, recreation, and so on.

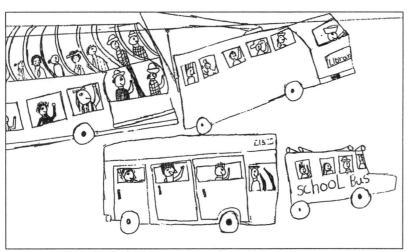

Draw Me a Story

Drawings transformed by computer graphics

David made a drawing of his school and later, in the computer lab, transformed it into the image at figure 9.19. As a requirement of the project, he wrote a note about the school which he incorporated into the presentation of the drawing. "Lord Strathcona Elementary School is where I learn. I like this school because there are two computer labs and we are the only elementary school in Vancouver that has a cafeteria."

Strathcona is one of the oldest neighborhoods in Vancouver and has a rich architectural heritage. Students were asked to draw some of the old houses in the surrounding community and to write about them. They used computers to transform drawings into souvenir cards for the centennial celebration. Leanna's drawing and her words are at figure 9.20.

Drawing a hero

Robert, who is in grade two, made this drawing of Terry Fox, the hero who ran across Canada to raise money for cancer research (figure 9.21). Robert's text on his picture tells the story. The idea in this drawing could be developed into a project where students research leaders in the community and illustrate the defining moment of their careers.

Figure 9.19 Lord Strathcona Elementary School, a computer drawing from an original sketch by David.

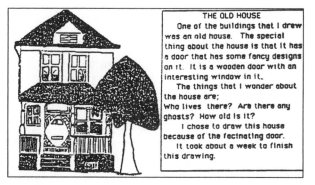

Figure 9.20 *The Old House* by Leanna, an intermediate student.

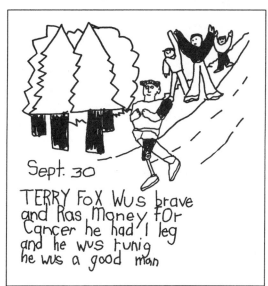

Figure 9.21 *Terry Fox* by Robert, age 8.

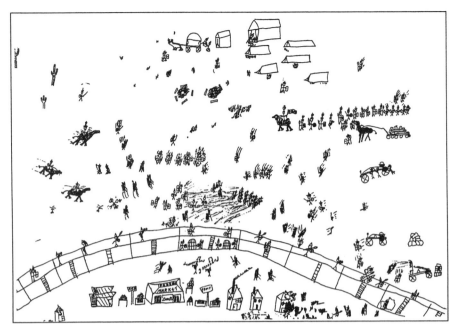

Figure 9.22 *Preparing for Battle* by Geoffrey, age 11.

Figure 9.23 *The Battle of Queenston Heights* by Mike, a middle post-naive boy.

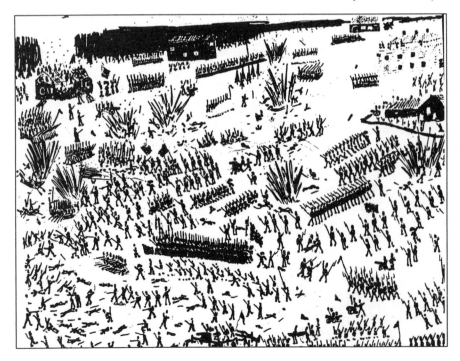

Drawing history, wars and battles

Many children draw historical events with concentration and take pride in showing detail. This can contribute to the study of history, particularly if it stimulates research and is accompanied by captions and written text. In *Preparing for Battle* (figure 9.22), Geoffrey chose to draw an imaginary battle from an historic period. His drawing is about a medieval siege.

Mike's drawing portrays the battle of Queenston Heights (figure 9.23). He had been introduced to the larger scope of Canadian history through reading and illustrating famous battles.

Drawing interesting people

In *Seal Hunt* (figure 9.24) we know from the sureness of line and the strength of the forms that Michael was experiencing empathy with the Inuit hunters who are approaching a family of seals. It is also an x-ray drawing, showing both the wavy underside of the ice and the smooth top. In positioning himself near the seals, Michael conveys an equal concern for them. The three hunters are small, emphasizing the vast spaces of the north, but, never-

theless, suggest determination to pursue the hunt. This drawing, photocopied as a class set or enlarged on a screen with an opaque projector, would make a good focus for class discussion.

Seal Hunt radiates aesthetic energy through a total integration of form and content and we must consider it an authentic work of child art. It incorporates subject matter from both science and social studies, an example of an integrated or holistic curriculum.

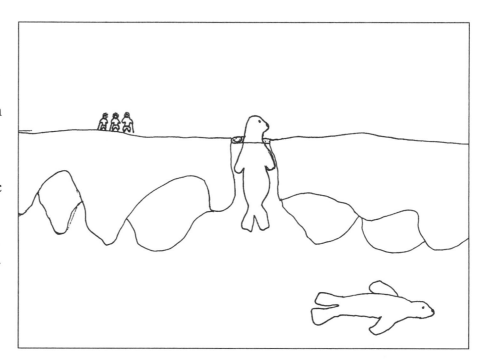

Figure 9.24 *Seal Hunt* by Michael, age 11.

The Mayan Project at Carnarvon School: A Model

The Mayan Project was an integrated unit in art and social studies. On the invitation of Katherine Reeder at Carnarvon Community School, I did a series of workshops with her grade five/six students. My original plan was to limit art to studio techniques, but as they were studying the jungle paintings of Henri Rousseau, I was able to bring art history and picture appreciation into the social studies unit. Rousseau provided an excellent model for drawing the Central American jungle from imagination.

Using teacher-prepared resource sheets

I prepared resource sheets of photographs and illustrations of Mayan art and architecture from magazines which I photocopied for each student. They were kept on file as

Figure 9.25 A composite sheet of prep drawings from a resource sheet of Mayan sculpture and architecture.

part of a resource library. The sheets were used to motivate line drawings and other graphic works. Students were asked to pay attention to archeological accuracy, although naturalistic drawing was not emphasized.

Prep (preparatory) drawings

Prep drawings are for learning and practice. (The term comes from professional artists' practice of using scratch pads to think graphically and to rough sketch forms.) Students use resource sheets to do prep drawings to help them memorize a graphic vocabulary (figure 9.25). These images are later used spontaneously in more finished work. Studying a wide range of historically accurate material adds authenticity to finished works. Students are given a resource sheet, a ballpoint pen and paper. The teacher identifies an image as the focus and directs one or more of the following activities.

- Examine the image and trace its contours in the air or simply memorize it .
- With eyes shut, visualize the image.
- With eyes still shut, visualize the drawing as it might appear when finished.
- With eyes open, make a continuous line drawing.
- Study the resource material again and make another drawing.
- After more study, make a drawing with eyes shut.
- Finish the sequence by making a drawing with eyes open.
- Project resource images on a screen and have the students draw them from observation as though they were real.

By concentrating on each image in this way, students evolve new schemata for future use. They study the material, but always before, never while drawing. This is memory drawing involving empathy and is different from copying,

which is purely mechanical. An alternative to individuals having resource sheets is to keep the material on a table at the front of the room to be referred to when needed. The important thing is to be able to study it, but always to draw from memory.

Mayan studies and Rousseau's jungle

Pictures from museums, and great art published in books, magazines, and posters, make useful models. A resource sheet based on Henri Rousseau's jungle paintings was prepared for the Mayan project (figures 9.26a and b). His jungle flora are not scientifically accurate. An integration with a science unit where the real flora of Central America would be studied is a possibility.

Visualizing an adventure story as a drawing

Writing stories in social studies is one way we can make learning more memorable. Children work together on researching, writing, and illustrating them, or on producing a comic book, play or video. At Carnarvon, because of limited time, I came with a story to tell. It begins with a plane crash in the jungle, near Mayan ruins.

Imagine that you are taking a plane trip over the Central American jungle. The plane is just large enough for you and your family. It is a cloudy day and you are forced to fly low. The lush jungle reminds you of pictures by Henri Rousseau which you studied in school. You fly over a clearing and see the ruins of Mayan sculptures and temple pyramids. You glimpse vines with flowers and large leaves climbing up the ruins and exotic birds with crests on their heads and long tails. You see monkeys on the tiers of the temple and a jaguar is slinking along the ground near a ruined sculpture.

Suddenly a tropical storm strikes and you are forced down in a crash landing. The pilot lands safely and no

Figures 9.26a and b A resource sheet based on Henri Rousseau's jungle paintings and a composite sheet of prep drawings done from memory after studying the Rousseau resource sheet.

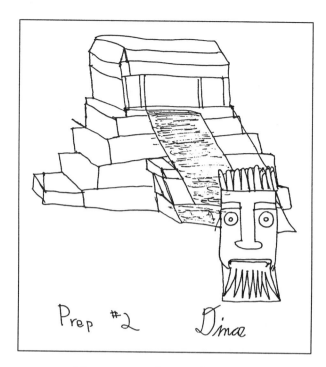

Figure 9.27 After studying resource sheets of Mayan sculpture and temples, a student made this prep drawing from memory.

one is hurt. *When you all climb out, you find yourselves stranded in the jungle. You begin walking out and suddenly you come upon a clearing. Directly in front of you is a large stone head, the portrait of an ancient Mayan ruler. It is so heavy that it is gradually sinking into the ground. It has been there for so long that it is slightly tipped to one side. It is a large head, about twice as tall and wide as your father. Beyond it, much farther off, are the ruins of a Mayan temple. The huge stone head blocks the view slightly, but you can see a second head much nearer to the pyramid.*

When the story was finished, students were asked to visualize the Mayan ruin, the stone heads, and the jungle clearing. Guided imagery was used to help them imagine where elements might be placed. How would the jungle look? the birds and animals? the pyramid? and the stone sculptures? How would they relate to each other? They must search for alternative compositions before deciding.

Imagine how everything will change as you get closer to the first stone head. Yes, it will get larger. Will you see more or less of the temple which lies beyond it? Of course, more of it will be blocked out by the overlapping plane of the head.

Guided imagery began as an activity conducted by the teacher, but students were encouraged to practise it on their own when planning their pictures.

The drawing game was introduced to help children get over the sense of drawing inadequacy typical of post-naives. The resource sheets were used for motivation as described above. (For a description of the drawing game, see Chapter Seven.)

Perspective

Overlapping planes and drawing distant things smaller are two ways of showing distance without having to be familiar with the mechanical rules of linear or vanishing-point perspective. Figure 9.27 is an example.

Preliminary and finished drawings

In her preliminary drawing of a stone head and three temples (figure 9.28), Suzy explored the principles of perspective and the features of Mayan artifacts. Social studies and art were simultaneously served. She then found ways to improve it in her second drawing (figure 9.29). She used modified drawing game strategy in both.

Introducing tone

Tonal development was introduced as an art activity to enrich the Mayan line drawings done in social studies. Tone is the range of light and dark values from white to black. There are three ways to use it, alone or in combination, to make forms look more three-dimensional.

1. Tone as a flat, unmodulated area of white, black or a range of grays. The effect is more abstract and decorative than three-dimensional. (See Jon's *Mother Mowing the Lawn*, figure 8.14, page 113)

2. Tone as the principle that light advances and dark recedes *when we draw it, but not necessarily as we see it in nature.* If we want to make an apple look three dimensional, the form, as it recedes from us, is gradually made darker. The principle would be reversed when landscapes are seen under certain light or weather conditions (the turbid medium effect). For example, a nearby tree may look dark against the light tones of a distant hill.

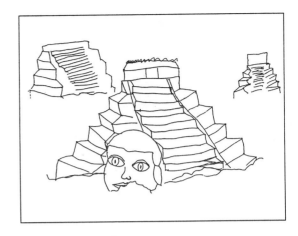

Figure 9.28 Preliminary drawing by Suzy, age 11.

Figure 9.29 Finished drawing by Suzy, age 11.

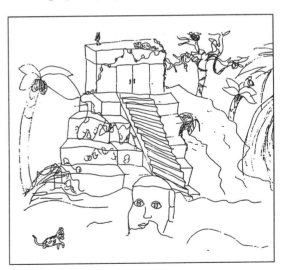

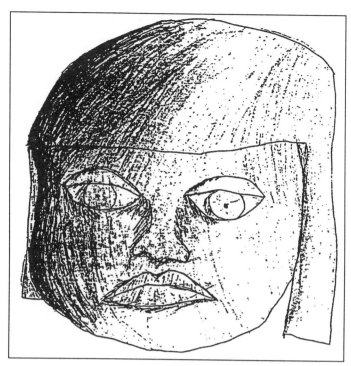

Figure 9.30 *Stone Head* by Suzy, shows light falling on the head from the right.

3. Tone based on an analysis of how lights and darks are distributed on the subject (figure 9.30). This applies to subjects that are seen, remembered, or imagined. There may be a problem when a shadow falls on the nearest form, making it difficult to use the principle of 'light advances, dark recedes'. To do justice to what we see and how the forms can be rendered effectively, the shadow may be modified (made less dark) and/or the form strengthened, perhaps with a contour line.

Children are more apt to use tone in flat patterns. We should be prepared, however, to give basic information on modelling forms (in tone) to older children when they request it. Mini-lessons in more sophisticated techniques can be taught to individuals when they are ready for it.

Applying tone

Tone is applied by using a drawing tool to make marks in all possible ways: soft pencil gradations; repeated dots, dashes, parallel lines, and so on. Dark areas are created by close textures and much overlapping; lighter tones by leaving more spaces between marks; gradations made by imperceptible changes in density from light to dark, dark to light.

In figure 9.31, the drawing of a Mayan priest in an animal headdress illustrates the use of tone to define forms based on the principle that light advances and dark recedes. To increase the illusion of depth, the children were taught to model the surrounding space in the same way they did the forms. Space can be made to bend by using the principle 'light comes forward, dark goes back'.

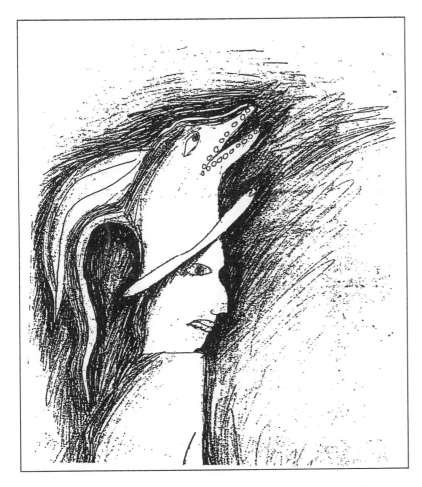

Figure 9.31 *Mayan Priest with Animal Mask* Anon.

Planning a picture based on the Mayan theme

The Mayan project combined instruction and the encouragement of personal initiative. Children planned their own pictures based on the themes and techniques they had learned, using the worksheet shown in figure 9.32 (see page 146) as a guide. In the final days of the project, I introduced graphic techniques that were new to the children: cut-and-paste, photocopying, and lift drawing.

Figure 9.32

```
PLANNING A PICTURE BASED ON THE MAYAN THEME

NAME:..................................

HERE IS A LIST OF POSSIBLE COMPONENTS: TRY TO INCLUDE AS MANY
AS YOU CAN.

STEP ONE: YOUR PICTURE SHOULD INCLUDE -

1. Some reference to the jungle.

2. All or part of a Mayan temple ruin.

3. One or more statues.

4. One or more human figures in costume.

5. One or more overlapping planes.

6. One or more examples of 'things get smaller as they are
farther from us.

 STEP TWO: DECIDE ON HOW YOU WILL ORGANIZE YOUR PICTURE:

STEP THREE: WRITE A FEW NOTES DESCRIBING THE PICTURE:

STEP FOUR: VISUALIZE THE ORGANIZATION OF YOUR PICTURE AND THEN
VISUALIZE THE DRAWING ITSELF:

STEP FIVE: DRAW THE PICTURE:

WRITE YOUR DESCRIPTION HERE:
```

Cut-and-paste, photocopying, and lift drawing

Enrichment, elaboration, tonal development, the natural textures produced by some media, these were the focus of a number of final art activities. The media were graphic in nature, drawing itself being a graphic medium, and a photocopier provided creative printing possibilities, as follows.

- Drawings from each student were photocopied. For greater design flexibility, segments of the drawings were enlarged or diminished. This made it possible for the students to apply the principles of perspective they had been learning. It allowed them to use overlapping planes and to show that things seem smaller when farther away. They cut shapes from the photocopies and assembled them with attention to design and dramatic presentation, then pasted them together as montages. Black construction paper was used as a mounting sheet, or to make additional cut shapes as a design element.
- Using the photocopier, students made these montages into small editions of prints. They could then trade with other students.
- We used a set of double 'L' viewfinders to isolate 'found' images within drawings and montages. The isolated image was cut out, mounted on black paper and photocopied. (See Chapter Six, page 86.)
- Lift drawings were made as follows: a thin layer of water soluble block printing ink was spread on glass with a rubber brayer; paper was placed face down on the inky surface, and a drawing made on the back of it. A variety of drawing tools were used, thick pencils, fine-point ball points, even fingers. When the paper was lifted, the image had been transferred to it. A drawing had been transformed into a print. Care was taken to get the ink roll-up the right consistency — thick enough to leave a mark and thin enough not to transfer marks to unwanted areas. The children experimented with 'wet' lines by using a heavier roll-up of ink and a thicker drawing tool, and 'dry' lines with a thinner roll-up and a fine ballpoint. Tone was applied by rubbing lightly on the back of the paper with a finger or by filling-in shapes with vigorous pencil marks. While it is increasingly difficult to find, carbon paper can be substituted for wet printing ink.

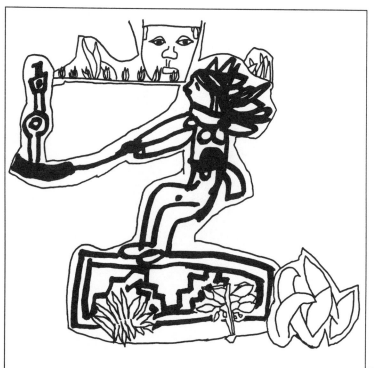

This certainly avoids ink's messiness but is not nearly so dramatic and satisfying to children.

A small edition of carbon paper prints was made by interleafing three pieces of drawing paper with two pieces of carbon paper and stapling them together for stability. Drawing with a ballpoint and using a fair degree of pressure, the image was transferred to the papers.

Figures 9.33a and b Two final images from the Mayan project, using various graphic techniques.

Celebrating the Storytellers

n many ways, drawing stimulates the use of words and thus the acquisition of literacy. Children think about words while planning a drawing; they conduct internal monologues or talk aloud to themselves as they draw; and put thoughts, words, and their drawing together in conversations with adults when the drawing is finished. The beginning writer can be encouraged to print words directly on the drawing. In Tyler's drawing (figure 10.1) his printed caption can almost be read phonetically: This is supposed to be Jesus on the cross. Adults may print words on the drawing either dictated by the child or as comments or questions. Sometimes entire conversations about the child's drawing are recorded or written down. These practices are commonplace in good kindergarten/primary classrooms. There it is understood that when children are read to and given opportunities to tell, write, and illustrate their own stories, it contributes significantly to literacy, intellectual development and affective well-being. On the other hand, widespread recognition of the dynamic relationship between words and drawings throughout the curriculum and throughout the years of schooling is negligible. Making better use of drawing in these areas is long overdue.

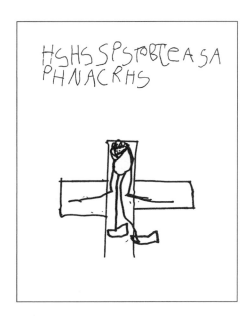

Figure 10.1 by Tyler, age 6. Tyler read his printed caption as "This is supposed to be Jesus on the cross."

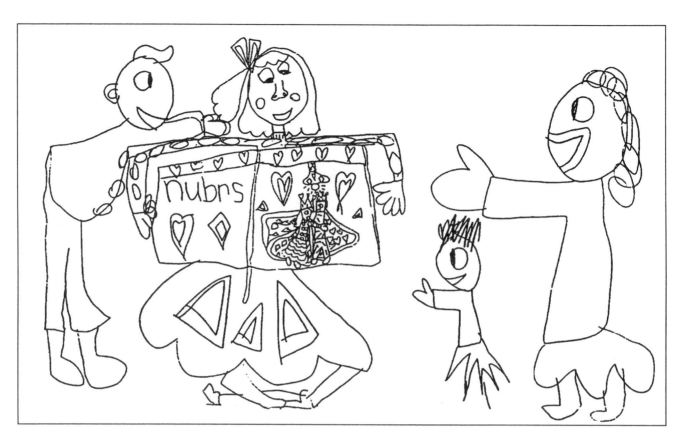

Figure 10.2 *A Family Reading Together* by Laura, age 6.

A Family Reading Together (figure 10.2) celebrates an enduring family custom, the bedtime story. In her drawing, Laura shows her mother seated on the floor holding a large book. The two children are on her left, her husband on the right. Mother is the center of interest and all arms point to her. Laura draws the figures with the abstract symbolism we would expect of her age. She uses her own schema with only minor changes to differentiate between them. There is no doubt that it is the mother who is reading and that she is a special person.

One Page Stories

TWO VOLCANO STORY/DRAWINGS BY JEFF

Jeff's drawing of a volcano (figure 10.3) prompted a conversation between Jeff and his teacher and gave him an opportunity to practice writing. The conversation encouraged him to use words he didn't yet know how to spell. The teacher wanted him to use them spontaneously; spelling would come later, a natural outcome of repeated use and spelling lessons. Moreover, she knew that children who write daily under guidance learn, in time, to use syntax correctly. To this end, the teacher commented on his drawing, "It looks very hot." Jeff responded, "Yes, it is hot." This approach doesn't preclude formal instruction, but it views conversation, writing and drawing, in the search for knowledge and understanding, as primary activities in gaining literacy.

Jeff's 'Volcano' reminds us that drawing is a language in its own right. Spelling and syntax were not needed to give the mountain its broad outlines, or to show the inner passages and vents through which vapors rise and lava flows. As an x-ray drawing, it shows both the outside and inside of the mountain, giving us more information than we would get from a more 'naturalistic' rendering. It belongs as much to science as it does to art or language arts.

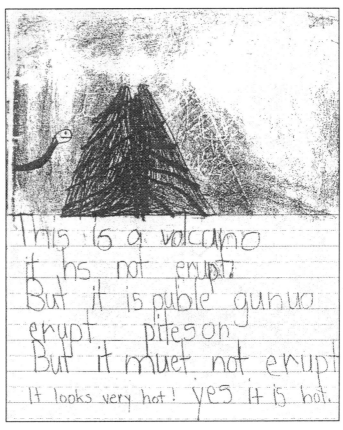

Figure 10.3 *Volcano #1* by Jeff, age 7.

When Jeff's mother showed me his drawing, I suggested that he might enjoy doing a second version. This time Jeff left out words, perhaps because it was done at home rather than at school (figure 10.4). He added a second reptile, omitted vents, and showed the volcano in a more active phase. I had suggested that he use only black and white, but Jeff, caught up in his story, asked at the last moment: "Do you think he would mind if I used a little red? "Fortunately, my injunction against color was not taken too seriously. The red details add a vivid graphic element. Imagine the drawing entirely in black and white as it is reproduced, except for a brilliantly carmine spine on the nearest animal, and red-hot coals erupting from the volcano's mouth!

Figure 10.4 *Volcano #2* by Jeff, age 7.

These two drawings are strong language expressions. The first, because it has words, may be more helpful to Jeff's growth in literacy, but the second is more original and, because its form and content are perfectly integrated, is a work of child art.

A teaching idea based on Jeff's volcano drawings

The volcano drawings could be used as a model for working with individual students, or an entire class. First, the children do a drawing and are encouraged to add words. After discussion, they plan a second version and are challenged to increase information, this time without adding words. They are then asked to explain the ways it contains more information than the first. Depending on their writing skills, the additional information can be recorded on

the back of the drawing. Thus they improve skills in speaking, writing, and drawing.

This teaching strategy could have been used in the following instance. Eddy and his class did drawings prior to a performance at their school by Maori dancers, perhaps relying on pictures for the costumes (figure 10.5). Afterward, they could have made a second version. 'Before and after' drawings stimulate comparisons in observation, drawing, conversation, and writing.

Comic strip format

We have already discussed the comic strip format but it is so useful in language arts that we will look at further examples here. Stories can be told using one sheet divided into 'windows', or separate sheets with a series of images. Words can be added as captions, or in word or thought balloons. When the comic-strip is finished, children can show their stories to the class and describe what they have done, or they can be asked to choose the most exciting panel and tell about it in greater detail. The comic strip then becomes the focus of a piece of writing.

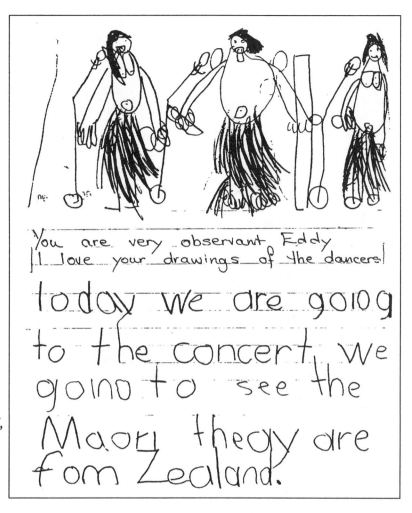

Figure 10.5 *Maori Dancers* by Eddy, age 7.

JAYME TELLS A STORY ABOUT HIMSELF DRAWING A COMIC STRIP

Jayme records the passing of time in his drawing *Spider Man* (figure 10.6). In box one, he holds a comic book and studies it. The time is shown on a digital clock. In box two, his drawing is on an easel and well underway. In box three, almost twelve hours later, it is nearly finished. In box four, Jayme steps aside and, with pride, pins the comic book and his copy of it on a tackboard. There is an important distinction: Jayme's drawing is about copying; it is not copied.

Figure 10.6 *Spider Man* by Jayme, an intermediate age boy.

ALEXIS MAKES A COMIC STRIP ABOUT A RESCUE AT SEA

Alexis' story is told in eight panels (figure 10.7). Children are caught in a wild storm at sea which reaches a climax in the sixth panel. At one point, they are in the water, but a whale appears and saves them, carrying them on its back. The sun comes out, and the children wave goodbye to their rescuer.

Teaching Ideas based on the comic strip format

The comic strip format can identify key moments and narrative details for use in planning a play, a video, or writing a story. Imagine this as a class project, the theme being the relationship between humans and nature.

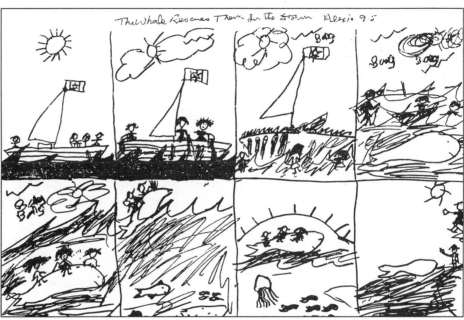

Figure 10.7 *The Whale Rescues Them In the Storm* by Alexis, age 9.

- Have each student make a comic strip adventure story about a group of children on a field trip and an animal that saves them from danger. Each panel highlights one part of the story and describes its location. When the drawings are finished, discuss them with the class as a whole, or in smaller groups. Choose one for further development.
- Next, have each student take the chosen strip and make a personal version of it, making changes and improvements, adding new dialogue. Discuss and evaluate the new strips and select one for production as a play or video.
- Let the class divide into small groups, with some working on dialogue and character development,

others on detailed drawings of costumes, still others on settings.

- If the decision is made to go ahead with a production, choose, with the class, a director, stage manager, set designer, props person, and technical crew and divide the class into working units.

Figure 10.8 Illustrations for *The Cay* by Wendy, Edward, Loan, Monica, Sherman, Vincent and Philip, grade six students.

Draw Me a Story

Illustrating and Writing Multiple Page Stories

Drawing pictures for unillustrated books

*The Cay** by Theodore Taylor is a good yarn which evokes vivid pictures. Its lack of illustrations makes it ideal for children to draw their own from their imagination (figure 10.8).

Using picture books as models for children's drawings

Rosie's Walk by Pat Hutchins** is a story for younger children. A primary teacher in South Park Family School prepared and photo-copied worksheets designed to motivate her students to read, write, and draw. Partial sentences were printed and students were asked to finish them. The rest of the page was left empty for a drawing. Neal, a gifted and imaginative storyteller chose as his theme for the story *Taking Jack the Dinosaur for a Walk* (figure 10.9) and went far

Figure 10.9 *Taking Jack the Dinosaur for a Walk* by Neal, age 8. Six drawings to illustrate and tell a story

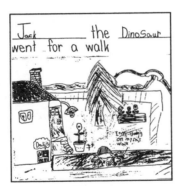
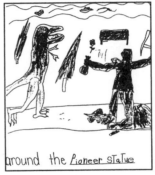
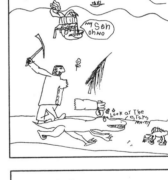
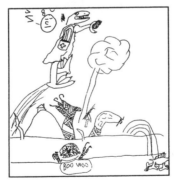

....................................

*New York: Double Day, 1992.
**New York: Macmillan, 1968.

beyond the outline provided by his teacher. Each page is filled with witty detail, extraordinary sophistication, and sheer fun.

Writing this story in words would challenge Neal, but follow-up conversations about his drawings would help him translate the visual images into verbal expressions, developing his vocabulary and syntax.

Making books at home: the story of Chris

Chris made his first book when he was in grade one. By the age of ten, he had produced fifteen, all done at home. This was an admirable achievement, particularly when there was little encouragement at home or in school. Only book #10, *Hockey and Football* (figure 10.10), has survived. The answers he gave to my questions give us insight into the lives of children who spend a lot of time writing and illustrating stories.

> *I started the books on my own, without much encouragement from anyone. They were important to me as expressions through words and drawings, and also I was interested in creating something with my hands — the books themselves.*
>
> *I drew in fits and starts, never consistently. Yes, teachers were aware of my drawings. No teacher ever opposed it. I drew a little after school, but mostly in the evenings. I drew alone. If I referred to pictures (photographs) at all, it was to try to create drawings that were as realistic as possible. I wanted things to be exact.*
>
> *Friends knew of my books, but took little interest. In school, other kids wanted me to draw maps, charts, and so on. I was never given special art projects. Once in a while I drew with friends, but rarely.*
>
> *None of the other books were on sports. Sports in general didn't interest me. Most of the others were adventure stories.*

Captain of Vancouver Canucks

4

Ken

Orland Kurtonbach

JAN 11-22 Ken is still Rookie And will be around as say Minnesota's Gump Worsly. Here He makes a Complete turn on one skate with the spin of his stickless arm providin the force. Save on chest.

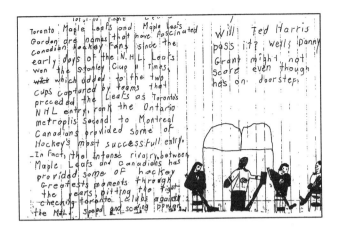

Toronto Maple Leafs and Maple Leafs Gardens are names that have fascinated Canadian Hockey Fans since the early days of the N.H.L. Leafs won the Stanley Cup 11 times, with which added to the two cups captured by teams that preceded the Leafs as Toronto's NHL entry, rank the Ontario metropolis second to Montreal Canadians provided some of Hockey's most successfull entry. In fact, the intense rivalry between Maple Leafs and Canadiens has provided some of hockey Greatests moments through the years, pitting the tight-checking Toronto clubs against the M.L. speed and scoring power.

Will Ted Harris pass it? Wells Danny Grant might not score even though he's on doorstep.

Ted Hampson beets down Ed Westfall with reft Neil Armstrong blocking bobby Orr it's a fight.

8

Bobby ORR Can He Score?

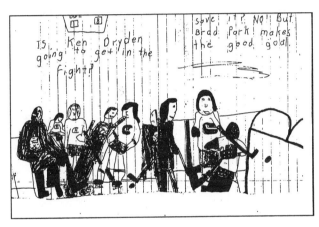

Is Ken Dryden going to get in the fight?

save it? NO! But Brad Park makes the good goal.

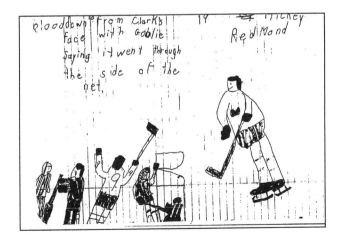

Blood down from Clarks face with Goalie saying it went through the side of the net.

14

Mickey Redmond

Figure 10.10 *Hockey and Football* by Chris, age 10. A five page story.

Color was very important, the most fun after outlining the drawings.

I barely remember drawing in the primary years but I do remember enjoying and creating things out of paper, clay, wood, whatever. I was exposed to many coloring books. I remember being very exact about what colors went where — to make them as realistic as possible.

I felt I was getting very good at art work but there was no real push or appreciation from anyone. I was my own best critic.

Joanne, Prolific Storyteller and Illustrator

We return to Joanne, the remarkable child artist who drew *Lucy Was Tired Now...* Since she had limited vision, she had to get very close to the paper to draw, but this did not discourage her. She was gifted with intelligence, energy, an indomitable spirit, and an unusual talent. She had many other interests including music, writing and sports. She was particularly knowledgeable about dogs, and drew them daily. Some of Joanne's dog drawings are without words but I include them here as part of her remarkable achievement.

Just as she was heroic in her determination to get the most out of life, despite her handicap, she produced stories cast in the heroic mould, the most extraordinary being the adventures of Lucy.

Joanne's nearsightedness probably contributed to the unusual quality of her drawings. Figures 10.11, 10.12 and 10.13 are fine examples of empathic realism which distinguishes authentic art from the surface qualities of naturalism. Although her family never owned a dog, Joanne

became familiar with the various breeds, and invariably stopped to make friends with them. She could not see a whole dog from a distance, and only part of a dog from closer up. She relied on book illustrations and spent hours poring over photographs and drawings, memorizing the images. Her mother told me that she never drew with a book in front of her.

I once watched her drawing when she and her mother visited me in my office. Knowing of her interest in dogs, I told her about our Sheltie. I had provided colored felts and drawing paper, and while her mother and I were talking, Joanne drew several Shelties being taken for a walk by their owner. Her concentration was intense as she bent low over the paper. We know empathy to result from perceptual integration, the sense of sight integrated with the sense of touch, real or imagined. Joanne may have compensated for poor eyesight with a stronger sense of touch, a deeper level of feeling.

Figures 10.14, 10.15, 10.16 and 10.17 (all on page 162) are examples of single drawings from some of Joanne's stories. The captions include the text Joanne wrote on each of her drawings.

Figure 10.11 *Bird Dog Scaring Up Birds.*

Figure 10.12 *Pointing Dog.*

Figure 10.13 *Seeing Eye Dog Running Away.*

Figure 10.14 *Merlinda Witch's Peaky Hat* "One day five year old Merlinda was learning how to write her name. A beggar turned her hat into a frog."

Figure 10.15 *Queen Thinness* "One day there was a very thin queen. Her name was Queen Thinness."

Figure 10.16 *'I feel so good. Where is my hat?'*

Figure 10.17 *A Deaf-blind Teenager With a Malinois Guide Dog.*

The Lucy Saga

When she was six, Joanne told the story of Lucy in a series of twenty-four drawings. We have discussed one of these, *Lucy Was Tired Now...* in Chapter Five. This is the story from which it was taken.

We pick up the story with figure 10.18 which builds to a climax with *Lucy Was Tired Now...*, figure 10.21.

Figure 10.18 reads "Lucy carried Billy, Lily, Jane, and Dawn. Though the load was too heavy. But she could still carry them all. She spotted Carol's house, Dora's house, Anne's house, and Frank's house." The drawing shows Lucy carrying her friends. Note the brush in her hand and the pail of red paint at her feet. 'Spotted' seems to be her word for painting the houses. Figure 10.19 is the first drawing to contain the form which later is used for Lucy's deathbed. Here it is used as a ground plane. In figure 10.20, the same form is made by the extended arm of the figure at the right (we assume it is Lucy) reaching to hold hands with the figure at the left.

Figure 10.18 *"Lucy carried Billy, Lily, Jane, and Dawn..."*

Figure 10.19 *"Then Lucy had lot more children to babysit. She still had more paint so she spotted Pinky's house Percy's house."*

For a discussion of the key drawing at figure 10.21, please refer back to pages 72-73. Figure 10.22 shows the final scene: "They took Lucy off the deathbed and then Lucy could still spot. She spotted Johnny's house." So reads the final drawing in the Lucy saga!

Not only did Joanne tell stories full of imaginative and humorous surprises, she drew with ease and her drawings were strong in 'the hidden order of art'. Supported by her own original text, they carry a content deeper than would have been possible with words. *Lucy Was Tired Now...* is of interest with its precocious reference to death, the source of which is

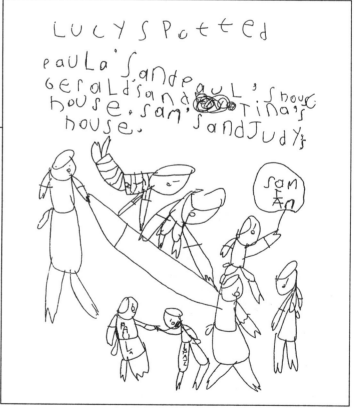

Fig. 10.20 *"Lucy spotted Paula's and Paul's house Gerald's and Tina's house. Sam's and Judy's house."*

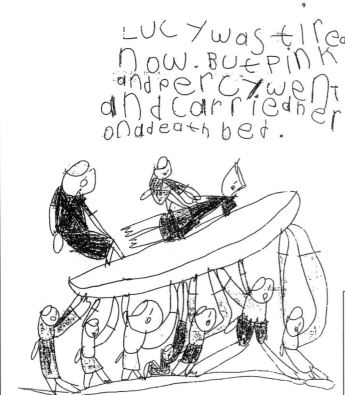

Figure 10.21 *"Lucy was tired now. But Pinky and Percy went and carried her on a deathbed."*

Fig. 10.22 *"They took Lucy off the deathbed and then Lucy could still spot. She spotted Johnny's House."*

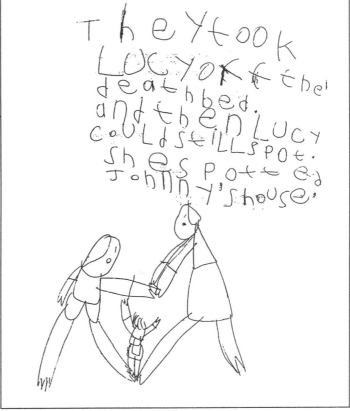

unknown. In the last drawing, we have the metaphor of rebirth: "They took Lucy off the deathbed and then Lucy could still spot" (paint). It seems that Lucy had been at death's door; now she arises, completely refreshed, able to carry on with her painting.

The themes of death and rebirth, unusual for a child even at the unconscious level, bring to a close what would otherwise be a six-year-old girl's typical adventure story. Whether you agree with this interpretation or not, the source of these astonishing images must remain a mystery.

Closing As We Began

The human mind-brain system is designed for functions radically different from and broader than its current uses. An astonishing capacity for creative power is built into our genes, ready to unfold. Our innate capacities of mind are nothing less than miraculous, and we are born with a driving intent to express this capacity.

I bring this book to an end as I began it, completing the inspiring quotation from Joseph Chilton Pearce. Nothing in Magical Child suggests that the author was thinking about drawing when he wrote it, but I have tried to show that the way children use drawing is "nothing less than miraculous" and, in my view, is language. We have largely failed, in our modern homes and schools, to educate children to their full language potential. In the end, we must all take responsibility for making the necessary changes that will enable them to express their "innate capacities of mind."

Glossary

Aesthetic energy A radiant and uplifting sensation experienced by viewers when form and content are integrated in a work of art.

Archetypes According to Carl Jung's theory of the collective unconscious, these pre-existent forms are part of the inherited structure of the psyche: themes that may rise to the surface of consciousness as myths, fairy tales, cinematic images, and so on. Some recognized archetypes are the hero, the mother, the lover, and the mischief-maker. Children's drawings (such as David's *Attacking the Snake* and Joanne's *Lucy Was Tired Now*) often seem to have as their inspiration these archetypes in the collective unconscious.

Articulation The largely intuitive ordering of the elements and principles of design; articulation leads to intellectual development, knowledge, mental health and aesthetic energy. The raw materials of art (perceptions, thoughts, and feelings) are chaotic; articulation is the process of creating meaning and emotional significance.

Base line When children move beyond the initial stages of representation (for example, when humans are depicted as tadpole figures), they use a base line to indicate a ground plane. This marks the beginning of placing figures in space.

Cognition The process of knowing, perceiving and learning. The forms of art are derived from intellectual processes as much as from feeling and emotion.

Conscious The most accessible level of consciousness, rational, logical, analytical, predominately verbal. (See also preconscious and unconscious.)

Content A synthesis of perceptions, thoughts, and feelings, associated with subject matter. The subject matter of *Boat Holiday* is a boat trip; its content is the thoughts and feelings evoked by this event. While form can be described empirically, content is an amalgam of the artist's intent and the viewer's subjective response. Its interpretation must be supported by an analysis of form.

Continuous line strategy The requirement that the drawing tool must be kept moving throughout. The effect is to place control in the preconscious. With practice, 'continuous line' becomes 'continuous performance,' allowing for brief stops to relocate.

Drawing game A remedial strategy to help post-naives regain their spontaneity; empathy for subject is invoked; visualization and guided imagery are used; continuous line and other game rules are followed; the teacher plays the role of coach.

Drawing-as-language A term to focus attention on drawing as a language medium. Children draw spontaneously in such a way that the definition of language is fulfilled.

Drawing Network An informal grassroots organization of parents, teachers, and academics devoted to the idea that children use drawing as a language which helps them attain literacy. It had its beginning in 1988 at the University of British Columbia.

Elements and principles of design The building blocks of visual art and the principles which guide their use. The elements are usually considered to be line, shape, form, color, and texture. The principles are repetition, gradation, alignment, variation, positive and negative shape, unity and so on.

Empathic realism When children draw actual, remembered, or imagined experiences with empathy, they achieve a sense of 'the real' without copying or using formulas. Naturalism aims to replicate the photographic appearance of forms. Empathic realism expands the definition of realism to include emotional responses, exaggeration, and a degree of abstraction.

Empathy When children draw, they identify closely with subject and appear to be 'at one' with process; the boundary separating self and other is softened.

Fold-over drawing Young children's attempts to solve difficult problems in perspective. They organize forms on either side of two base-lines, falling on either side of them. The paper is shifted to maintain a frontal relationship to the forms.

Form The elements of design (lines, shapes, tones, textures and colors) and the principles that govern their articulation. Form without content is mere pattern; content without form, mere illustration. In works of art, form and content must be integrated.

Formula art Illustrations designed by adults for coloring-in or copying; crafts based on step-by-step procedures; visual stereotypes.

Guided imagery See 'visualization' below.

hidden order of art, The A phrase coined as the title of a book by Anton Ehrenzweig. It describes the formal relationships in works of art not immediately perceived.

'I can't draw' syndrome In the intermediate years, children become aware of themselves as individuals in a peer group. This leads to self-consciousness and a loss of spontaneity which often continues throughout life. Strategies to counteract this syndrome become important in retaining drawing's usefulness as a language medium.

Inner screen of the imagination The phenomenon of being able to imagine, for example, *seeing* a house when the word 'house' is used even though no house is visible.

Museum without walls Andre Malraux's phrase for art as it appears in various media, including art books, magazines and slides.

Perception Awareness of the world through the senses; the child's primary source of imagery. Lodged in memory, sensory impressions are the raw material of knowledge and intellectual processes.

Perceptual feedback As children draw, they watch the emerging image appear on the paper. Information flows back to the preconscious as perceptual feedback. The pre-conscious thus takes control of the drawing's development.

Picture plane The flat surface of the paper on which drawings are made. Flatness, size, vertical/horizontal ori-entation, and the relationship of horizontal to vertical dimensions, all affect the way the elements and principles of design generate aesthetic energy. The picture plane con-tributes to a 'sense of the real' by playing a double role: first, it defines a real surface for compositional structuring; second, it makes possible the illusion of depth and space, necessary for empathic realism. When children draw, the picture plane becomes an extension of the 'inner screen of the imagination.'

Post-naive A new word for identifying three age groups — older children, young people and adults — who have similar problems of self-consciousness in drawing.

Preconscious The intuitive mental process that operates just below the level of consciousness, active in day-dream-ing, synthesis, scanning, stream of consciousness writing and drawing, brainstorming, etc. In drawing, young chil-dren have easy access to it; older children and adults find it more difficult.

Rational thought Conscious deliberation and analysis; in art, pictorial analysis. In the drawing process, rational thought comes into play when themes are discussed, fin-ished products analyzed and evaluated. In game drawing, it is important to by-pass its effect by keeping the pen moving over the paper; premature analysis or criticism induces self-consciousness. The continuous line

rule (in the drawing game) frustrates rational thought by making it impossible to 'catch-up' with the drawing's momentum.

Schema Abstract symbols created intuitively by children as a graphic vocabulary. These are amalgams of perception, thought, and feeling, and are used repeatedly until no longer needed. **Schemata** are stable for the most part, but, like adding adjectives and adverbs to nouns and verbs, they vary slightly according to where and how they are used.

Scribbling The first exploratory mark-making. This leads to 'naming the scribble' when a figure is recognized in it.

Sequence drawing A spontaneous way of depicting several events in one drawing.

Symbolic abstraction When children first begin to make representational images, they draw simple forms that symbolize complex entities, such as their universal use of 'tadpole figures' for humans.

Texture A variety of mark-making techniques: scribbles, parallel lines, dots, dashes, cross-hatches and so on. A drawing begins with line and its forms are elaborated with tone, texture, and color.

Tone A range of values from light to dark, white to black. Children use tone sparingly to fill-in areas for contrast and emphasis. Early drawings are sometimes elaborated with scribbled-in tone, for example, to indicate hair. Older children use it to add realism to their drawings.

Unconscious In the words of Dr. Lawrence Kubie* the location of "complex constellations of conflict-laden and repressed ideas, feelings, memories, and purposes." While not directly accessible, the influence of the unconscious may appear as neurotic symptoms, compulsive behavior, and rigidity. The cathartic effect of art is one way of modifying, even healing, its negative effects on personality and the soul.

Visualization and guided imagery Visualization is our ability to 'see' on the inner screen of the imagination. In guided imagery, adults coach children with words to help them visualize themes, to imagine alternative scenarios, or plan a sequence of images or events.

*From *Neurotic Distortion of the Creative Process*. New York: Noonday Press, 1961.